NED PRATT

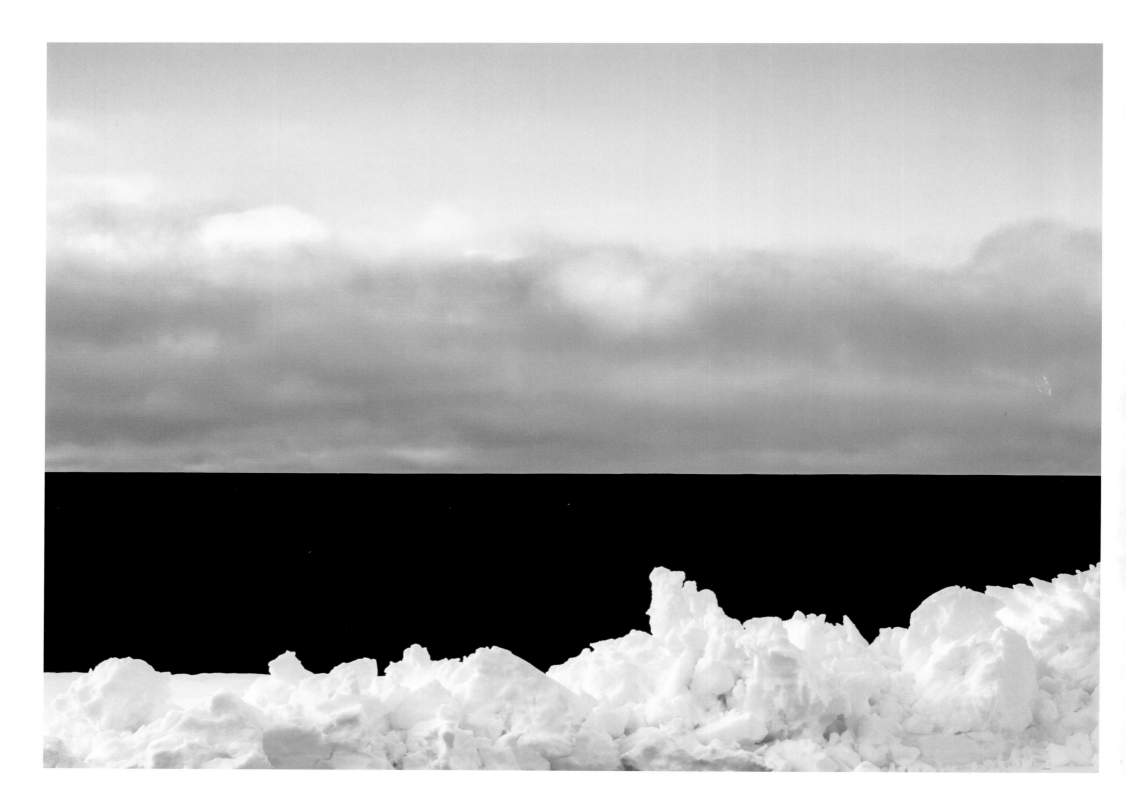

St. Philip's Beach, 2016

NED PRATT

ONE WAVE

Goose Lane Editions | The Rooms

In memory of Mum

Mary West Pratt

1935-2018

Contents

Foreword

Over the past ten years, Ned Pratt has created a remarkable body of work that portrays this province in a sophisticated, highly formal manner. He shows us the beauty of a quiet moment in a rugged and difficult place. Pratt's respect for his home island is central to his aesthetic. He knows this island well and travels its roads waiting for an image to reveal itself to him—whether a shed in the snowy barrens, or a single wave crashing over a sea wall. The highly composed and elegant images transcend the usual narratives. They reveal to us the act of looking, rather than the place itself.

A key part of our role at The Rooms is to celebrate exciting and significant artists from Newfoundland and Labrador. Pratt is undoubtedly a powerful voice from the art community of this province. As a result, he has received considerable acclaim both nationally and internationally. Among his many successes, he was the only artist from this province to be featured in the landmark exhibition *Oh, Canada* at the Massachusetts Museum of Contemporary Art in 2012–13 and has been highlighted at recent art fairs in Toronto and Miami.

Our exhibition and catalogue act in dialogue, with the publication providing considerable insight into the works. I wish to thank the essayists who contributed their remarkable voices to contextualize Pratt's photography: Ray Cronin, Mireille Eagan, Sarah Fillmore, Jonathan Shaughnessy, and Pratt himself. Thank you as well to Christina Parker and Nicholas Metivier for their considerable aid throughout this process. A tremendous thank you to the staff at The Rooms for their dedication and hard work on this project. Finally, our sincerest gratitude and congratulations to Ned Pratt himself.

ANNE CHAFE
Director, The Rooms Provincial Art Gallery and Museums Divisions

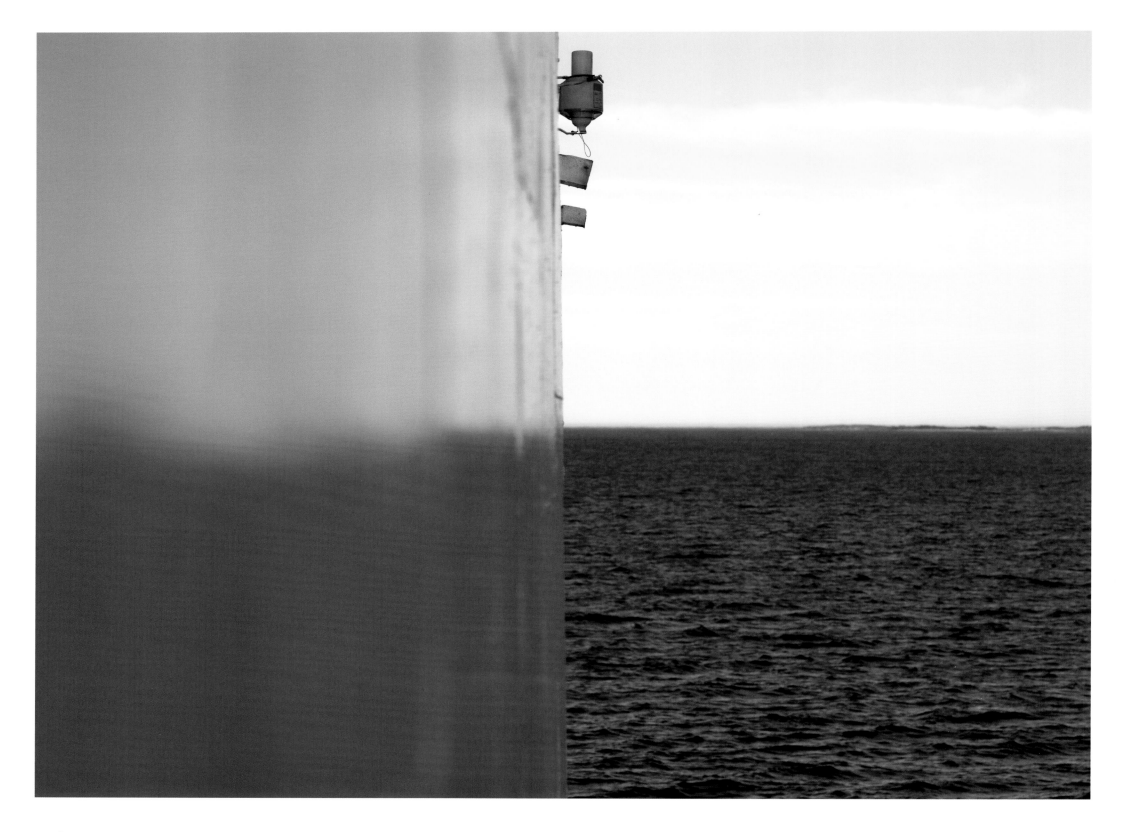

Fogo Ferry, 2010

LOOKING FOR SEEING

Ned Pratt

I am very fortunate to have grown up in a home where the seemingly mundane was taken seriously. I, too, was always interested in observing the life around me—much like the child of a fisherman helps out on the wharf or makes small boats out of wood. Of course, I took it for granted at the time. I think we—my brother and sisters—all did. It was simply life. There were always books about the history of art and different artists neatly stacked on shelves in our home. The language of observation was always around.

Work I considered abstract interested me the most—the work of Piet Mondrian and Marc Chagall, in particular. Later, when I was studying photography, I discovered André Kertész, Robert Frank, and Lee Friedlander, among others. Then, of course, there are my father and mother, Christopher and Mary Pratt. Even as a young man, I never understood why Dad was referred to as a realist. To me, he was always an abstract painter. As was my mother. I felt the term "realism" somehow sold their observations and efforts short. It is obvious that they have both influenced me. And I say, respectfully, that this can be a source of great frustration when you are trying to speak in your own voice. It's impossible and artificial to deny the things that you are honestly drawn to. The issue was how to accept that reality and move on with some independence.

At first, I felt limited to what subjects I could photograph in Newfoundland. Artists, family or not, have explored this island for so long and so well that it's hard to find a place to insert your vision of things. When I first started putting serious effort into this body of work, I felt as if I was left with the dregs. By "dregs" I mean the things around us that others didn't seem to see or take seriously but

which I saw every day. It is in the dregs that I found—and continue to find—my visual world. It is here where my interest in the abstract has helped me. I came to realize that abstraction is not the sole property of painting and sculpture.

The temptation to work in certain ways is so strong in me that I'm often frustrated. I see more things that I can't photograph than things that I can. At times, I just go ahead; at other times, I go ahead and try to undermine the composition with carefully placed wires or other non-traditional composition elements. Basically, I try to destroy the first impression and rebuild it at the same time into a different kind of beauty—something I can claim as my own.

My work relies heavily on composition. It is like a game to me, finding that one position that brings a series of complex, unrelated shapes into one unified observation. I am very interested in what happens when elements come together in a composition. When one visual mass approaches another, a tension is created. That tension can happen in multiple places in an image, or it can occur in only one place. In the end, the result is the same—a quiet stability is achieved. That is when I feel an image is complete: when I am left with no questions about what is outside the picture plane. When I am satisfied by the quiet stability of what I am looking at. Then, when the image is made, I don't really have anything to do with it anymore. I am an observer, like anyone else who comes to it. Yes, I am responsible for it, but I am left with no memory of the process of getting there.

In truth, these restrictions have led me to a place where I am at least somewhat unique. The nature of my process means that I am not able to create anything from what is not there. I have to find these elements. They must exist in that time, in that relationship, and in those conditions. I can't take away things and I can't add things, though I can change perception through composition and abstraction.

This simplicity exists, and I have found it.

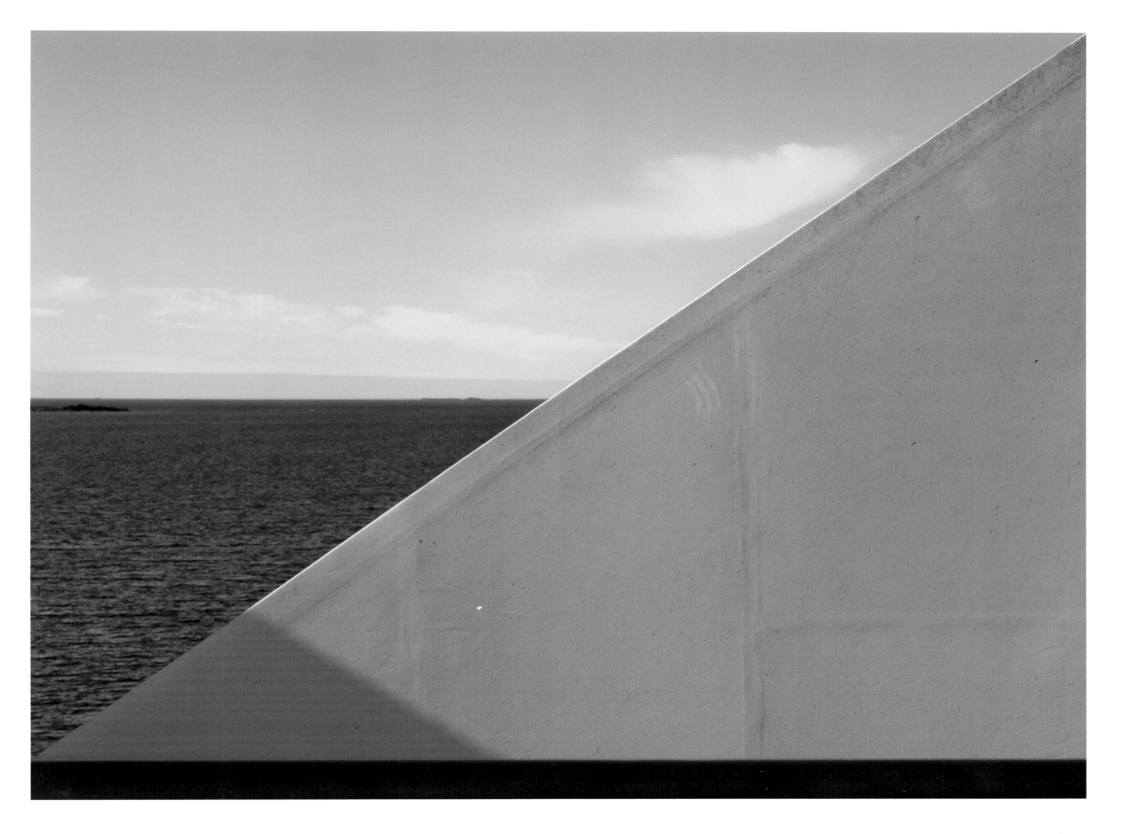

New Ferry, 2016

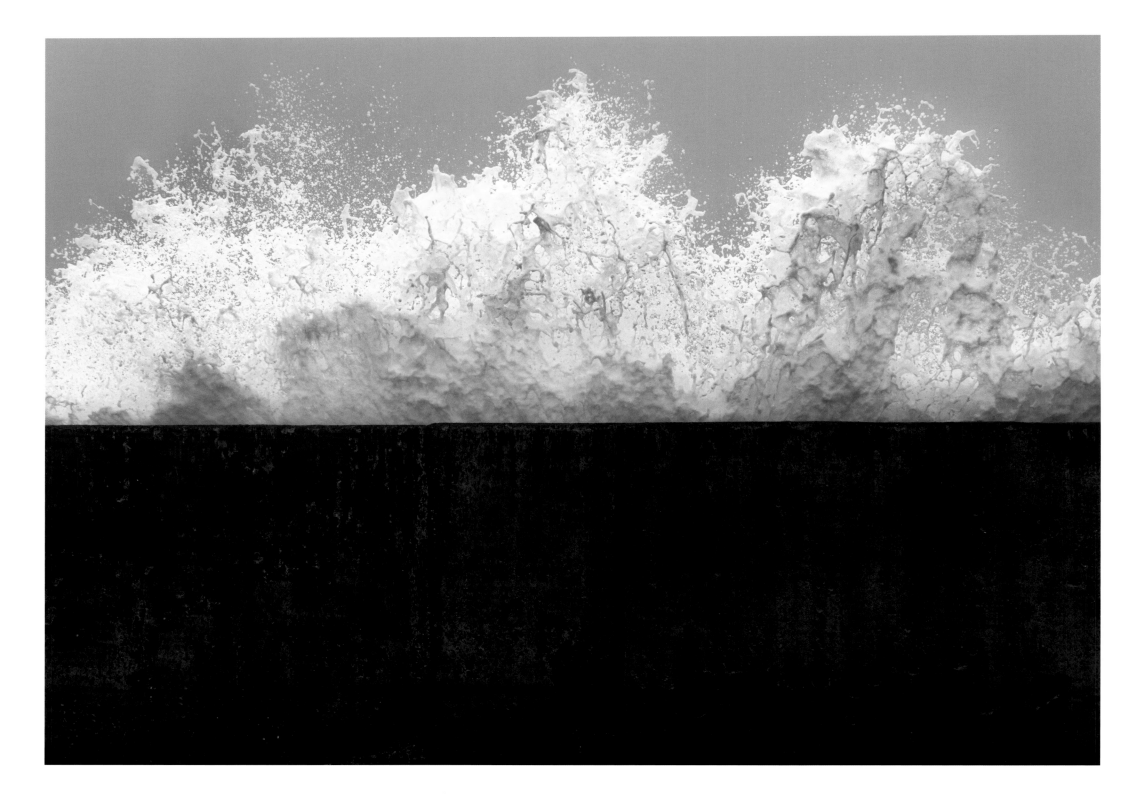

One Wave, 2016

An Interview with Ned Pratt

ONE WAVE

Mireille Eagan

Mireille Eagan: I consider you an artist of contradiction in many ways. Your images often seem to be two things at once. Primarily, they hold a connection to your relationship with this place while also seeming to negate it. Let's deal with the elephant in the room right away—your parents. You search for the image that jumps out at you, much like your mother. Your travels around this island and your crisp compositions are reminiscent of your father. The connection to their aesthetics and processes is one that you struggle with, yet you acknowledge it, embrace it, and engage it in your work.

Ned Pratt: You have to accept it. You can't just deny your connection because if you don't acknowledge the way you honestly see the world—and the way I see the world is the result of growing up surrounded by these types of images and ways of thinking—then the work you're doing is sort of a lie. You have to admit the influence is there. Once you deal with it you are led to other things, and you start seeing things that are your own.

My earlier photography was much more related to my family, but acknowledging that allowed me to move away from it. I do get frustrated with it, and I do have techniques that I use. I think of it as undermining the tendency to see a certain way. So I will create an image that I think is sort of easy or typical, and then I will put something in it that will tear it apart.

Miller Mechanical [*Miller Mechanical, Trinity Bay*, 2008, p. 15] was the first time I realized that I could photograph something incredibly simple while undermining an approach that I couldn't escape,

and in the end make something that was beautiful and my own. When I saw it I thought, "There is my voice."

Eagan: A common conversation that I have with Newfoundland artists of this generation is a conflicted sense of ownership that they feel about the visual language of this place, which they associate with artists such as David Blackwood, Christopher Pratt, and Gerald Squires. They were almost untouchable. But now this next generation is actively responding to and adapting the aesthetic of these artists, and developing a lineage as a result—a sort of visual call and response. How might you fit into this?

Pratt: You have to go ahead and do it. Do it the way you feel. You can't do it any other way.

Eagan: You have told me that you consciously break the compositional rules of photography to make the viewer aware that the photograph is an object and confront viewers with awareness of themselves looking at the photograph.

Pratt: Yes, but the act of confrontation is pretty quiet. Looking at it doesn't make you yell. I've never seen anyone look at my pictures and stomp. Here's a great title for the show: "Ned Pratt: Not Prone to Violence." All kidding aside, what I try to accomplish is a challenge of subtle movements, changing people's perceptions.

Eagan: How much do you think about the viewer when you are composing the image?

Pratt: You've got to make sure that you make room for the viewer, even though that is something I don't necessarily think about. I don't think about the viewer very much, but I acknowledge the viewer. You have got to make an image where there is a place for the viewer to make it their own.

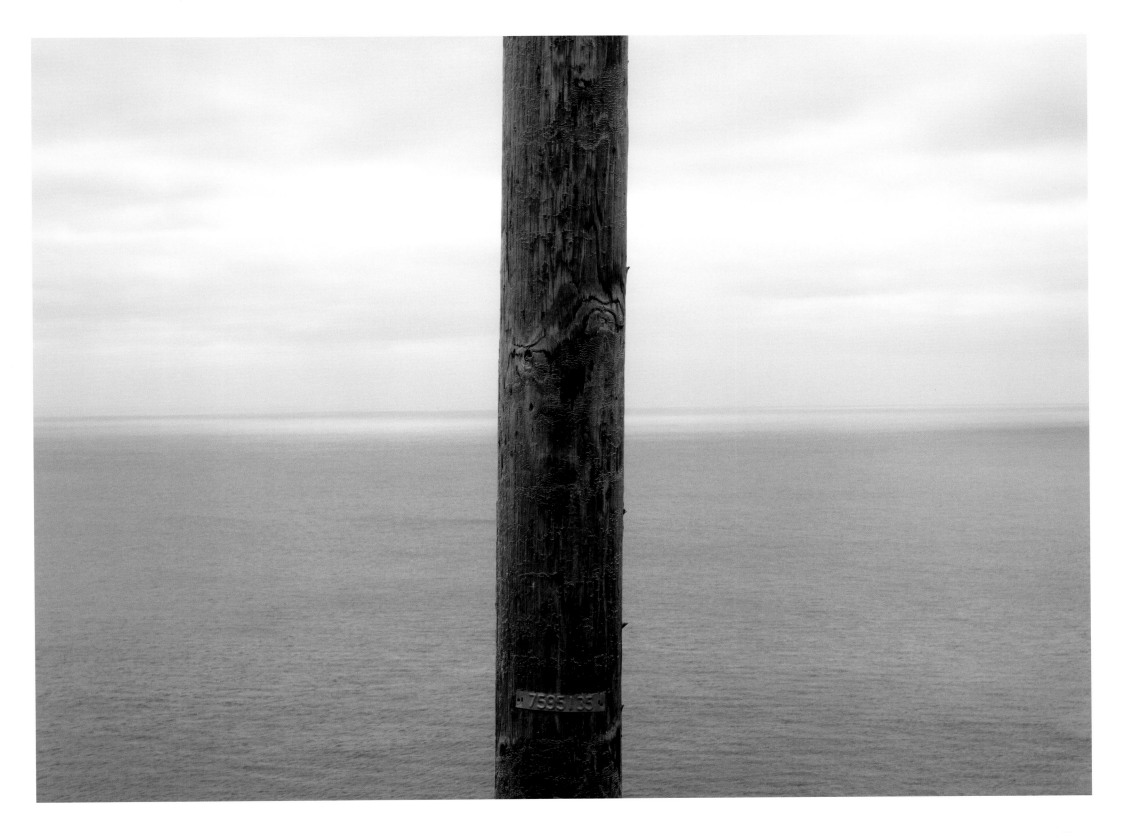

Miller Mechanical, Trinity Bay, 2008

Images, and people...people need to be able to take an image and feel a sense of ownership or a relationship that is distinctly their own. At the same time, openness is inherent to the form of the work. For the image, it can't be my place, it has to be their place.

Eagan: Who is the one looking at your image? Who is the viewer?

Pratt: Who is looking? Me. It doesn't matter if anyone looks at them or not. It is very gratifying when people enjoy what you do, or enjoy what you're making, but really I'm the one looking at it. When everything is done I feel like I'm looking at it like anyone else, because I feel detached from my role in the creation of the image.

Eagan: Why do you feel detached?

Pratt: Because somehow it exists on its own. It takes on its own flat life. It's a complete structure or a complete entity somehow. And I don't remember really being there or taking the photograph because I am satisfied. It is no longer about the place, but the feeling you have in front of you. Now certain photographs of mine seem simple to take, but they're not. They're quite complicated. So the really complicated ones I will remember, but primarily because of how fun they were to take. It's the game to take your machine—because I don't really think of them as cameras anymore—and to force shapes to react to each other in a way that they usually don't, and at the same time make them feel comfortable with each other.

 To talk about my imagery is like trying to take a nest of emotions and experiences, pull it into a line, and present it to someone so that they see the line, but when you are thinking about it, you see a nest.

Eagan: Let's talk about the act of storytelling. You often describe an interest in removing narrative from your work. Why is that?

Pratt: Photography—a huge part of it—is packed full of narrative. I think it makes it less beautiful in a way. I do want things to be beautiful, but I don't want them to be beautiful because of a story they tell, or a story they remind you of, or a memory you have of a place you spent time in. I want them to be beautiful because they are there, and you are looking at them and find a beauty in the form. I want beauty to be found in the composition and the creation that's in front of you. I do try to keep narrative to a minimum because that gets in the way of the form of the image.

Eagan: The Newfoundland you portray is a rare experience, if arguably non-existent. You describe your images as a search for quiet, but we live in a place where the weather shifts every fifteen minutes.

Pratt: The sense of quiet in my images comes through the composition as opposed to what is actually happening around me. It's this flat composition, with very little sense of direction or vanishing point, that creates the quiet. . . . You are faced with these walls, and it's generally very still. Motion is often stopped at the peak of its energy—like that image of the one wave [p. 12]—something that is still at the very top before it starts to descend. So something can go up or down, toward or away from you, but I don't like things to go across.

Eagan: Yet with works such as *Trailer with a Red Stripe* (p. 23), you seem to invite horizontal movement.

Pratt: It does bleed through the image but doesn't force you to follow it. You can if you want to, but you're met with the sorry edge of the photograph. It's just leading you to a wall.

Eagan: You have stated that your approach requires familiarity with this place—a knowledge of what is located where, but also an understanding that isn't romanticized. You have stated that you could not photograph anywhere else. I quote from an interview in the *Oh, Canada* catalogue: "[My works] do deal with memory and place. I am very familiar with the areas I like to work in, and have been for all my life. The more you go to a place, the more you see, obviously, but the repetition also deadens you to the easy beauty of an initial experience. One sees more subtly; I often feel lucky for seeing things that many miss, and the tones and shapes are those of my childhood. Grey days, simple structures. I didn't see it as beauty then. I wanted to be in town [St. John's]."[1]

Pratt: [laughs] I really did.

Eagan: Such a great quote. However, you have described photographing other locations as simply "exercises in composition."[2] Can you elaborate on why familiarity is so important?

Pratt: I think I have to stop looking at things like that because I want to apply my interests outside of my home. But, starting out, that is true. The way I justify such simple images is through my familiarity with the place. It sort of justifies a sense of poetry in the place, whereas if I were to go and work in China, for instance, and apply my approach to things, then it would just be an approach. There would be no history there for me. It would be about fear and claustrophobia, and trying to make that place look like Newfoundland. The work wouldn't have the same backbone.

Eagan: And yet for many people your images transcend this place. The architecture you photograph is perhaps the aspect of your imagery that is most recognizably Newfoundland. In particular, the recurring image of the shed is a highly Newfoundland-specific motif in your work—the blackened space of the black shed, the red shed, the yellow shed. What would happen if you went elsewhere?

Pratt: It's about form, and the fact that I have been photographing sheds for such a long time. It's

nice to see what you can do with them. If I went elsewhere, like the Prairies, and photographed a building there, it would be different. It would become a romantic thing then; it would become a shed in the Prairies. Whereas here it's such a repetitive experience that there's no romance for me in it. I really have to stop photographing the bloody things—they're like a children's drawing of a house [laughs]. But not every shed will do. There's got to be something intrinsically interesting.

Eagan: With larger architectural forms you consider details, but the sheds are placed centrally in the image—contained in the frame. They stand, often solitary, in the landscape. They seem almost like portraits.

Pratt: I don't see them as portraits. I see them as outlets. I really like photographing them, because I like the repetition of the form, the game of placing them in the landscape, and how I find that there is always a correlation in the landscape with the simple form that locks them in place. For the black shed, for example, I went to Port-au-Port just to get that image, because I knew the Peninsula had black sheds. And it was there. You sort of imagine it being there, and you go and you actually find it.

Eagan: Quoting from past interviews, you have described photography as "an invasive thing to do, even to an unoccupied landscape."[3] You also have described familiarity as providing a particular type of permission: "Familiarity helps me feel I have a right...or permission...to draw attention to something."[4] Can you expand upon that?

Pratt: I feel permission to take a photo of it in a certain way. You can photograph what you want, but I'm talking about permission to take an approach, and that approach is simple, minimal, and can only be earnest if it is the result of looking at a place for a long time so that you can boil it down to what's essential. And that is how I feel about things.

Eagan: Would you consider your images respectful of this place?

Pratt: Yes, but I have to admit I don't think of it like that. I think photographs by their nature should be respectful, whether a portrait or a landscape. They are respectful by not using the devices that are inherent to photography to exaggerate one way or another, whether positively or negatively. It is very easy to make something look either dire or sentimental, but it is the point in the middle where you are being respectful. You come closer to an accurate document.

Eagan: I'm going to get painfully theoretical here for a second, so bear with me. The sublime—an experience that is both uplifting and impossible—is a significant aspect of your work, it seems, in a fascinating way. It exists in an image's formal arrangement. In the *Analytic of the Sublime*,[5] Immanuel Kant suggests that the sublime emerges only when viewed from a certain point—an effect of precise alignment. If too far away, such as looking at a mountain, then he states that "the apprehended parts…are presented only obscurely…and if one gets too close, then the eye needs some time to complete the apprehension from the base of the peak." Add to this the fact that the Latin root of "sublime" is "sub" (up to) and "limen" (literally the top piece of a door). It suggests that there is no sense of the infinite that does not make reference to the placing of a limit or threshold. Is this relevant to your work?

Pratt: I understand the sublime very well. The sublime is something that scares you as well as entices you—that horrifying, enticing proximity. There is always an area in the image where you have this tension caused by proximity of shapes and forms. That proximity—that closeness of something that is somehow both massive and fragile—is what gives an image interest that you might not understand or see right away. It's a feeling that is created—the tension of proximity. I think everyone has it, everyone observes it, but it's not something that most people realize or take seriously. It's something I enjoy working with.

Eagan: How do you find your images?

Pratt: You just look. You look and you wait. You wait not only for things to happen around you but for your mind to get to a place where you can find images. Because it's not only a matter of going out and working, your mind has got to clear out.

Eagan: I remember you once saying that it took you three days to find an image. The first day you carry everyone with you—the expectations of curators and dealers. The second day they are still there, but less. And, on the third day, you find the image.

Pratt: It's not a trance but rather a specific way of thinking and seeing. It comes in bursts, and you can get a lot of work done in a short period of time when your mind is seeing things properly. Many things happen in your peripheral vision, for example, but also in your peripheral thinking. You remember something you just drove by, and you put it together. It jumps back, and there it is. With a clear mind, interesting observations come to you unexpectedly.

Eagan: I can't get away from how your identity plays into the images, or perhaps even the conscious evacuation of that identity. The images are very much you—they are straightforward, generous, confident, and yet also somehow impenetrable. Would you consider your images to be self-portraits in any way, or am I way off the mark?

Pratt: In a sense my images are self-portraits. They are autobiographical in that they deal a lot of times with the search to find a place in a visual world, but also just the joy of looking at things. So there is frustration, but essentially at the end, it's the joy of seeing things…which is your own way.

Everyone wants to be something, to make something. I've always wanted to feel unique about myself in some way, but there's nothing interesting about me...except perhaps in the way I think.

You described my work as confident. I'm not confident about my work. If you're confident, then you stop looking. If your ego is developed about your work, then that is what your work is about. So it can't be about that. But confidence...I think it really is a social confidence, which is really a bit of a farce...it's not there at all. Because I'm getting older, I care less what people think about me, but I always assume people don't like me.

Work is freedom from all of it—from guilt, from pressure. I'm not doing anything wrong when I work. My mistakes are controllable. I can go back and look at them and fix them, but I can't do that anywhere else in my life.

In a way, the conversation isn't about me—it's a conversation about things that happen. It's about things that happened to me, things I see, but it's not really about me. It's about things that filter through me.

This is the edited transcript of Mireille Eagan's interview with Ned Pratt on May 24, 2018.

1. Denise Markonish, *Oh, Canada: Contemporary Art from North North America.* (Cambridge, MA: MIT Press, 2012), 333. The catalogue accompanied the exhibition *Oh, Canada* (2012-13) curated by Denise Markonish and held at the Massachusetts Museum of Contemporary Art in North Adams, MA, which toured from 2013-16.

2. Markonish, 334.

3. Markonish, 334.

4. Markonish, 334.

5. Immanuel Kant, *The Critique of Judgement*, translated with an introduction and notes by J.H. Bernard (London: Macmillan, 1914).

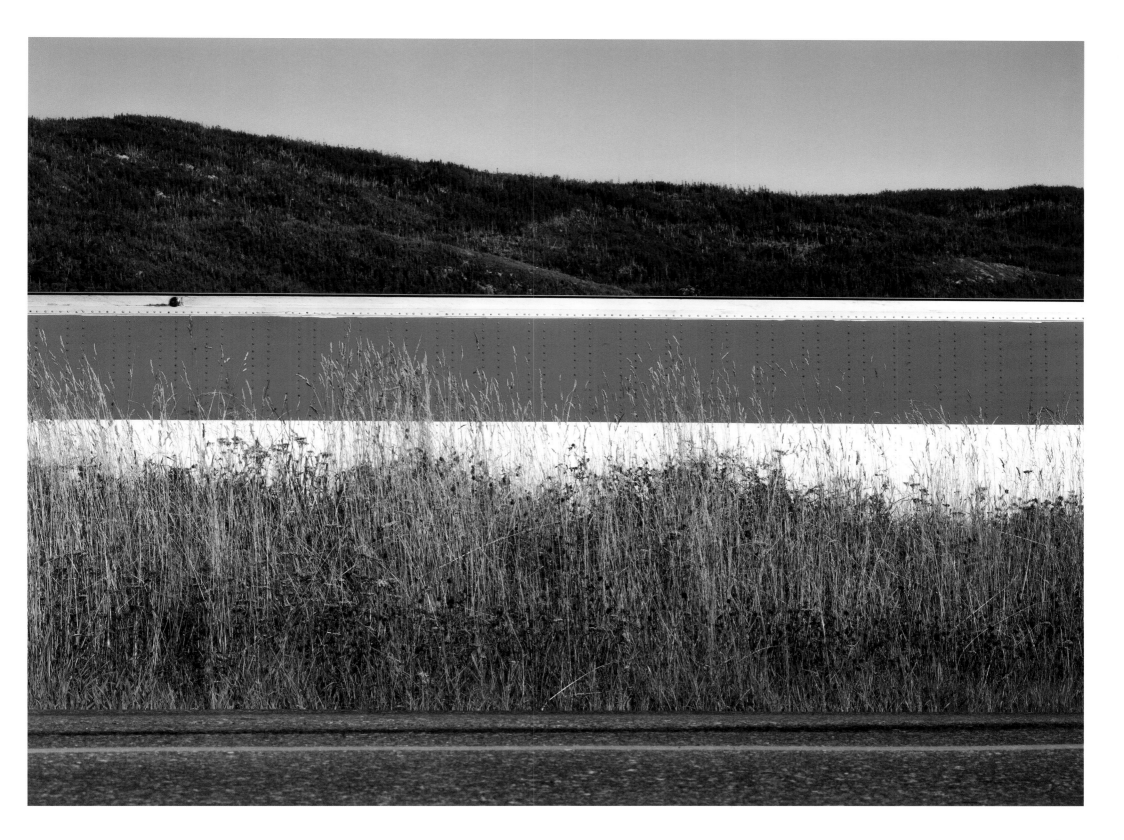

Trailer with a Red Stripe, 2011

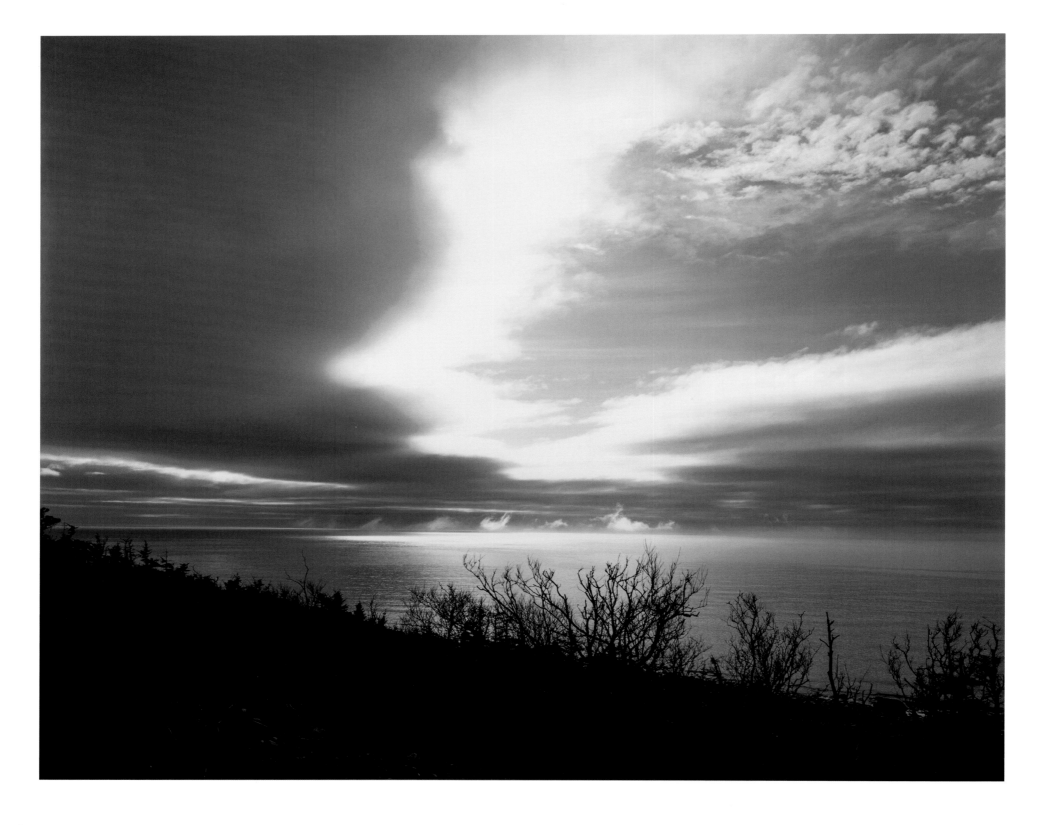

Blue Sky, 2001

CAPTURING THE ELUSIVE INSTANT

Sarah Fillmore

Ned Pratt commits to photography's promise to capture what the eye misses in a split second and in a particular place. Working with a digital Hasselblad camera and shooting directly in the field, Pratt demonstrates the artistry and seduction of the photographic medium, rendering the elusive light, feeling, and power of an instant.

Pratt came to photography as a student of art history and architecture. His personal experience of art and architecture goes back to his earliest days, as his parents (Christopher Pratt and Mary Pratt) are well-known painters and his uncle (Philip Pratt) is an established architect, who, as it happens, designed The Rooms. The aesthetics that surrounded his youth certainly inform Ned's contemporary practice, but historic influences have also crept into his aesthetic, framing and shaping it, evolving the way he trains his camera on land, sea, field, sky, and the built elements he finds there. One does not need to know this background to see it; it's impossible to deny the formal visual construction that lies in his compositions, and it's clear that his early experience and training formed the foundation, walls, and roof of his practice.

Beyond the circle of influence from immediate family, about which much has been said, Ned Pratt fits into a great history of photographers who have been drawn to the medium for its ability to capture the world around them, frame it with intention, and reveal qualities about that world that remain elusive through other means.

Initially interested in the social and documentary role the camera could play, Pratt looked to artists like André Kertész, Lee Friedlander, and Weegee. His training at the Nova Scotia College of Art

and Design in the 1980s introduced him to that institution's dedication to conceptualism, imprinting on him its mantra that the idea reigns supreme. This training, which manifests in Pratt's work as intention, creates a framework for his formalist output.

Pratt makes mention of his first job, photographing for the "good but controversial" St. John's-based newspaper, the *Sunday Express*.[1] As photographer for that newspaper, he expressed concern that he capture his subject with integrity—and with intention:

> Working at the newspaper taught me what I like and don't like about photography. It made me believe that I had a responsibility for the images I made. It made me see the power it could have and the damage that it could do. I wasn't cut out for the newspaper world.
>
> I photographed my subjects for the story I was given. If the story put them in a bad light, then I made sure my photo did too. But personally, I didn't know what was true and I didn't know the issue, really. Who was I to condemn this person by making them look one way or the other? I didn't feel qualified for those types of judgments. I still don't.[2]

In his own practice, Pratt's work has veered away from depictions of people toward other subject matter: images of the land, sea, and surroundings in the unyielding geography of Newfoundland. Photographers are frequently compelled to try to capture an elusive and fleeting quality of light. Ned Pratt's *Blue Sky* (2001, p. 24) is a perfect example of this, capturing a crack in the clouds through which a rich beam of light enters. It is views like this of his home province—carefully and, dare I say, lovingly photographed to reveal its unflinching beauty—that evoke Edward Weston's rich, romantic views of Death Valley and California from the late 1930s and 1940s. Yet where Weston saw dunes of sand, Pratt sees snow crust and ice.

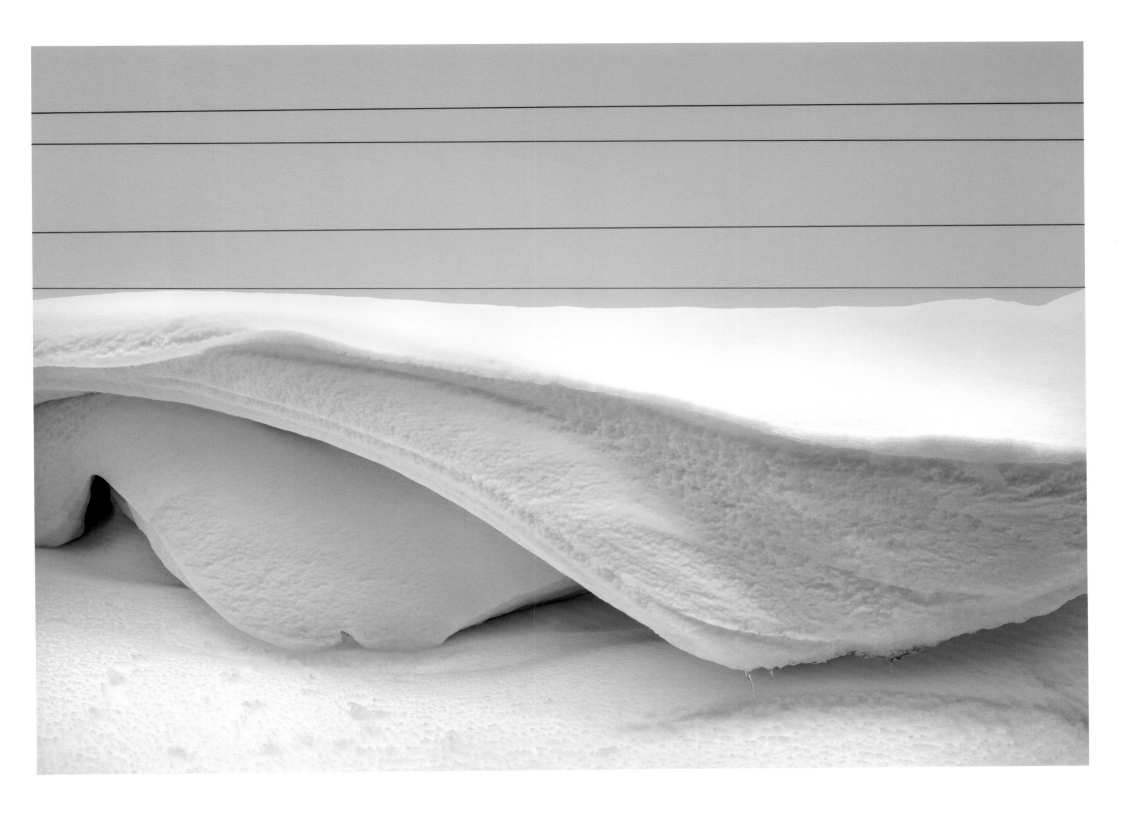

Below a Drift, 2017

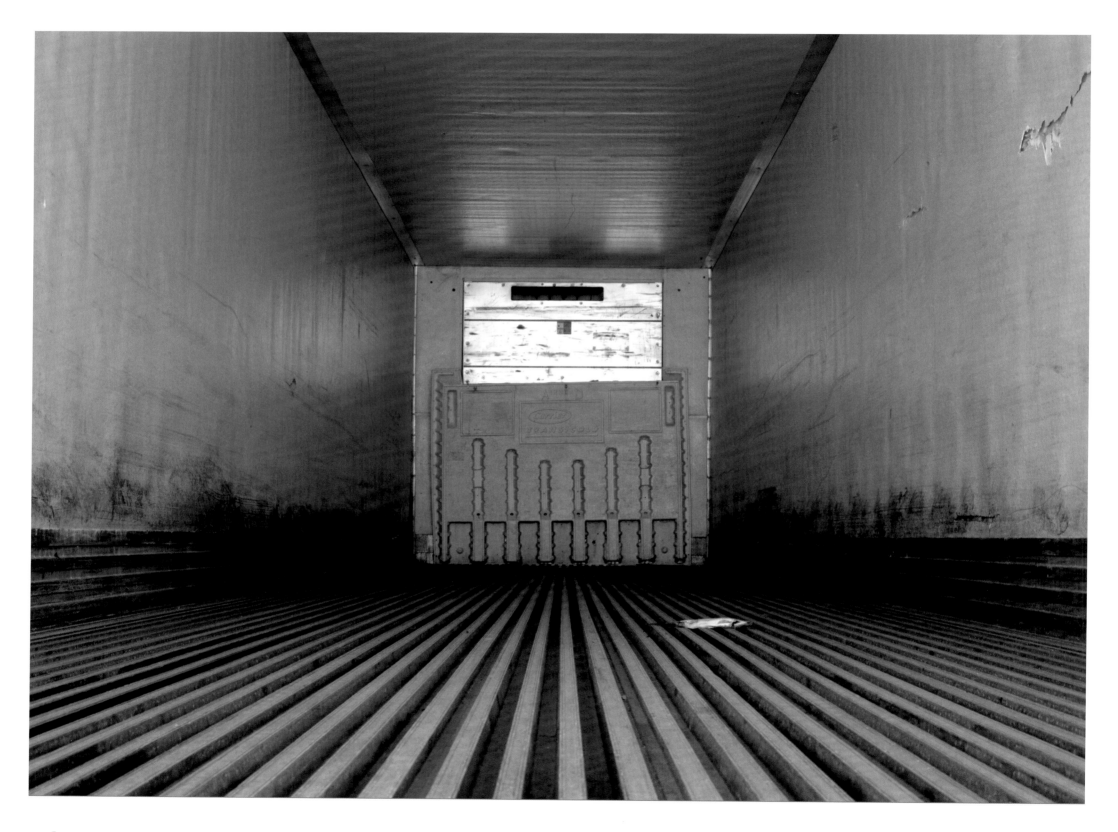

Transicold Trailer, Herring Season, 2011

American photographer Paul Strand (1890–1976), a key figure in American modernist and formalist photography, is another influence in Pratt's work. Early in his career, Strand's images were romantic and narrative; however, as the twentieth century took shape he left that aesthetic behind, instead favouring modern compositions that valued shape and form. His studies of shadow moved the image into the abstract, teasing form from story. Modernism partly emerged from an artistic and social desire to live more simply, away from the stresses of industrialized, capitalist societies. Modernism questioned tradition, the role of religion, and the division of the sexes. Poets and musicians, as well as authors and painters, found inspiration and voice in this fresh world view. New technologies, such as cameras, were adopted as the natural tools to advance "modern" ideas and aesthetics.

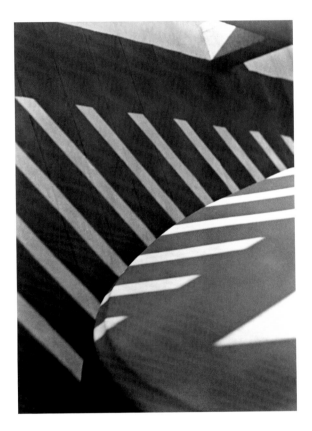

Strand's contemporaries—Berenice Abbott, Imogen Cunningham, and Alfred Stieglitz, among others—were key to establishing the modern aesthetic in photography. Coupled with the drive toward social change that took place following the First World War and the Great Depression, they saw the power of this medium to affect audiences. As Pratt also discovered while working at the *Sunday Express*, the printed image, with its easy distribution and immediate readability, held great sway. Modernist artists evacuated narrative from their subject matter and focused on form: colour, shape, and shadow.

Like Strand and his cohorts, Pratt finds a focus in the shape of things, anchoring his composition in the basic tenets of formalism. While the ideas and aesthetics of modernism were fresh in the 1920s, they became a stale cliché by the 1960s. Pratt finds a way to pick up the modernist thread, to breathe new life into the basic ideas of simple composition and formal presentation of shape and matter.

Paul Strand, *Abstraction, Porch Railings, Twin Lakes, Connecticut*, 1916

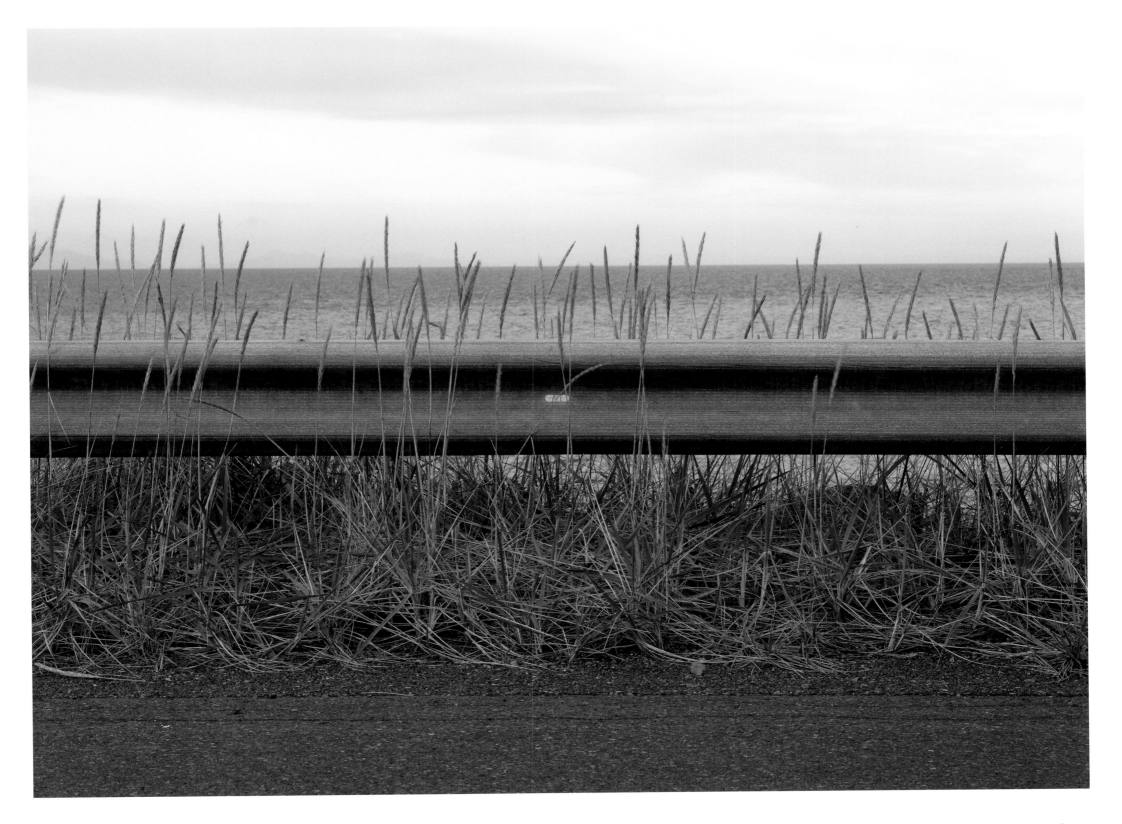

Guardrail, 2009

Ned Pratt's work demonstrates the extraordinary power of photography—as a documentary tool as well as a creative mode of expression. Focusing on his beloved Newfoundland, Pratt sees its shapes and colours as informing elements of his compositions, layering the land and sea and fog as a painter adds glazes and sfumato to a canvas. The word "photograph," coined in 1839 by Sir John Herschel, is based on the Greek word *phos*, meaning "light," and *graphé*, meaning "drawing." If we see photography as "drawing with light," Pratt's practice emerges as an organic, active one in which the camera and the eye work to sketch or draw what they see.

Parallels can be drawn between Pratt and American photographer Tod Papageorge, who turns his camera to the crumbling ruins of Athens and its white-hot light. Papageorge's student and now colleague, Lois Conner, shares Papageorge's wanderlust. The temples of Angkor Wat and the imperial gardens of Beijing's Yuanming Yuan (Old Summer Palace) provide the architectural framework for Conner's studies of light.

Lois Conner, *Engraved Moon through Parted Clouds, Yuanming Yuan*, 1998.
Platinum print. 17.78 x 43.18 cm. Reproduced courtesy of the artist.

Fog Bank at Cape Race, 2017

The quality of the light in Atlantic Canada has been admired and captured by many photographers, who have remarked on its particular luminescence. Sable Island, a protected island with a year-round population of five, is known for its virtually untouched natural vistas, a population of wild horses introduced to the island in the 1600s, and sweeping sand beaches. In a series of photographs dating from the decade 1986 to 1996, New Brunswick's Thaddeus Holownia portrays the wild properties of this southwestern extension of Nova Scotia. His use of a large-format banquet camera emphasizes and frames the landscape, capturing its almost liquid light. Like Pratt, Holownia

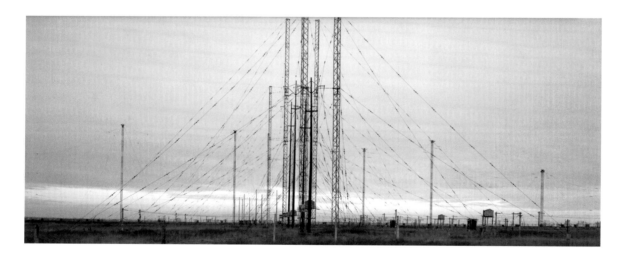

has dedicated his life and practice to the Atlantic provinces. He celebrates the land and sea that surrounds him in Newfoundland, Nova Scotia, and New Brunswick. And like Pratt, Holownia makes monumental the ordinary structures and detritus of life here. His images of the Tantramar Marsh and its spiderweb of wires, connected to the now-defunct RCI broadcast headquarters, offer a tense read on communications; this is echoed in Pratt's *Insulator* (2014, facing page), whose cruciform composition adds a religious note.

Thaddeus Holownia. *RCI, Tantramar Marsh*, 1979. Reproduced courtesy of the artist.

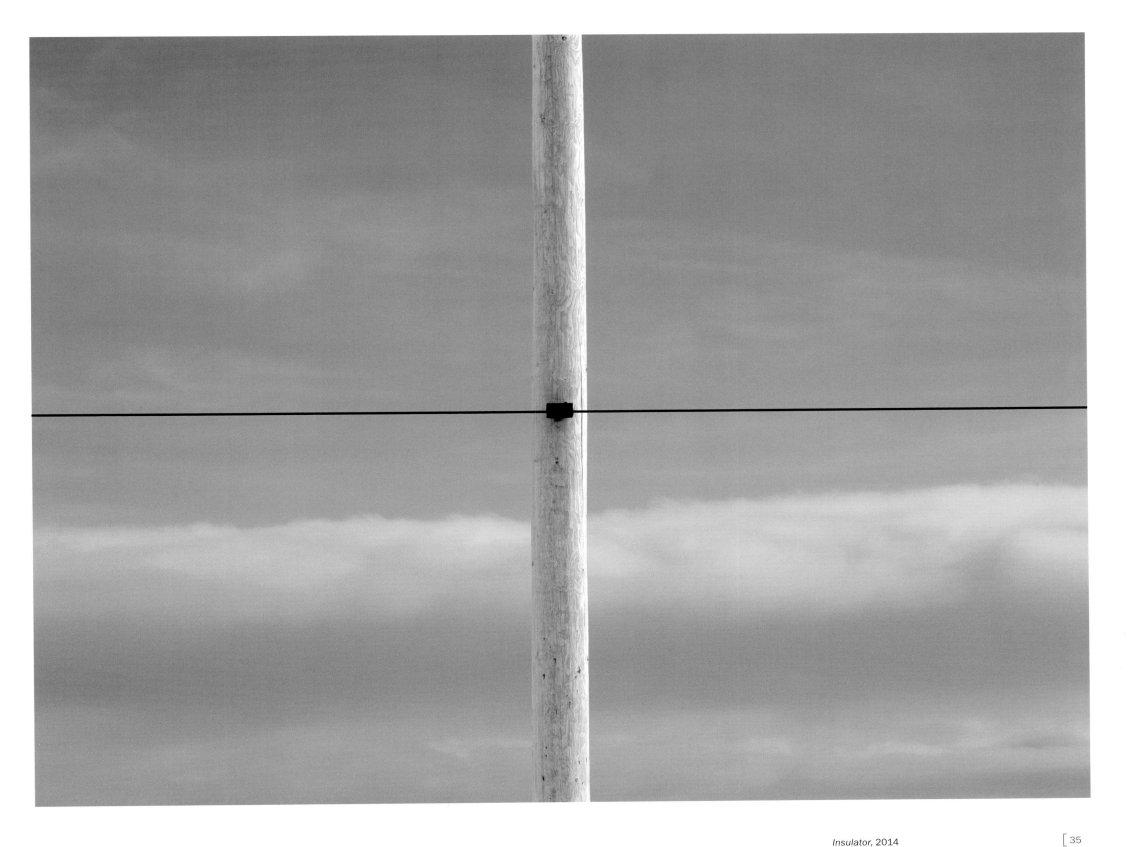

Another photographer with aesthetic links to Pratt is Cora Cluett. She framed the ocean view through now-abandoned military structures dating back to the Second World War, creating a tense pairing of architecture and natural elements. Using architecture to frame the scene is a familiar trope in photography, but Cluett's views, specifically framing the Atlantic Ocean, resonate with Pratt's own framing mechanisms. Pratt's use of rails, windows, wires, and fences has repeated throughout his work, offering hard, linear elements of composition within his organic, or natural, land- and seascapes.

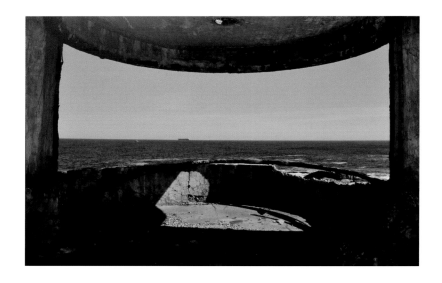

Like Pratt, Cape Breton–born photographer Tim Brennan also captured a remarkable quality of light in his views of Detroit, Michigan. Despite declining automotive production and an increasingly dilapidated urban shell, Brennan was able to find images of quiet dignity there. His views of shuttered factories and abandoned gas stations, redolent with light, raise the subject matter to a state of grace and quasi-nobility. In his own way, Pratt turns his lens to sheds, docks, and fences with a similar celebratory effect, elevating the mundane to monumental heights.

Brennan quotes artist Robert Frank, a neighbour of his in Cape Breton, as an influence. Frank's stark, no-nonsense views of America during the heyday of beat poetry and national unrest became a rallying cry among those whose voices were seemingly unheard. Brennan, a musician as well as a photographer, elected to add his own poetry to the frame. Pratt does the same, echoing a cry to his own generation, through his photographs—urging the unseen corners to be seen, the quiet spots to be heard, and the edges of his (and our) world to come into sharp focus.

Franco Fontana's geometric compositions of the 1970s and 1980s advanced the role of colour photography. His landscapes—blocks of bright, and pure, often primary, colours—read as abstract paintings. His work stands as a strong and brave statement, proclaiming the medium's capacity as an art form untethered to documentary content.

Ned Pratt's compositions resonate with the work of these other artists, proclaiming the medium of photography as ultimately the one most up to the task of rendering the shapes that form the alphabet for the language he speaks. His compositions recall the language of semaphore. He reads messages in the land, dock, and sky that fill his frame. Once again, the architecture of the natural world is shaped by his eye and by his camera—and meaning is made in that split second of shutter speed.

1. "Interview with Ned Pratt: An Unforgiving Landscape," in *Mason Journal*, December 31, 2011. See www.mason-studio.com/journal/2011/12/ned-pratt/.

2. "Interview with Ned Pratt: An Unforgiving Landscape."

Tim Brennan. *32nd Street*, 1999. Chromogenic print on Kodak Professional paper, 76 x 101.5 cm. Collection of the Art Gallery of Nova Scotia. Purchased with the support of the Canada Council for the Arts Acquisition Grants program, 2015. 2015.13. Photo: RAW Photography.

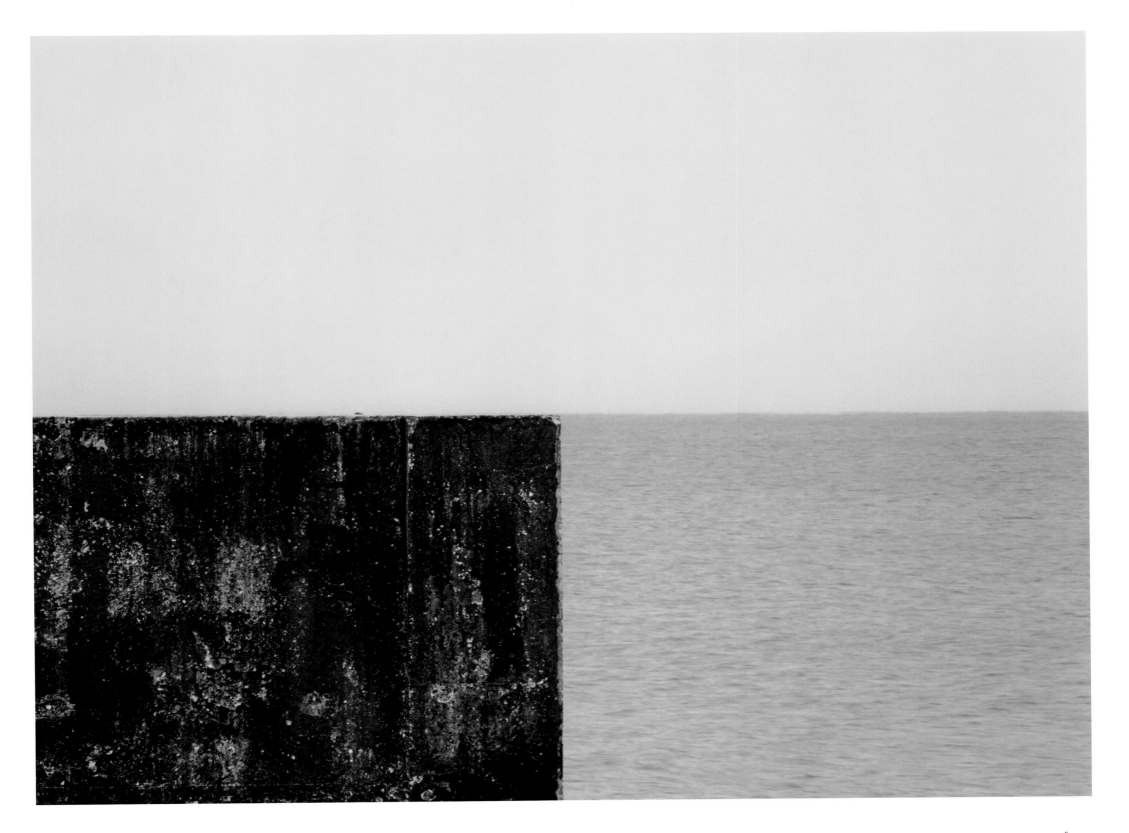

Harbour Entrance, 2015

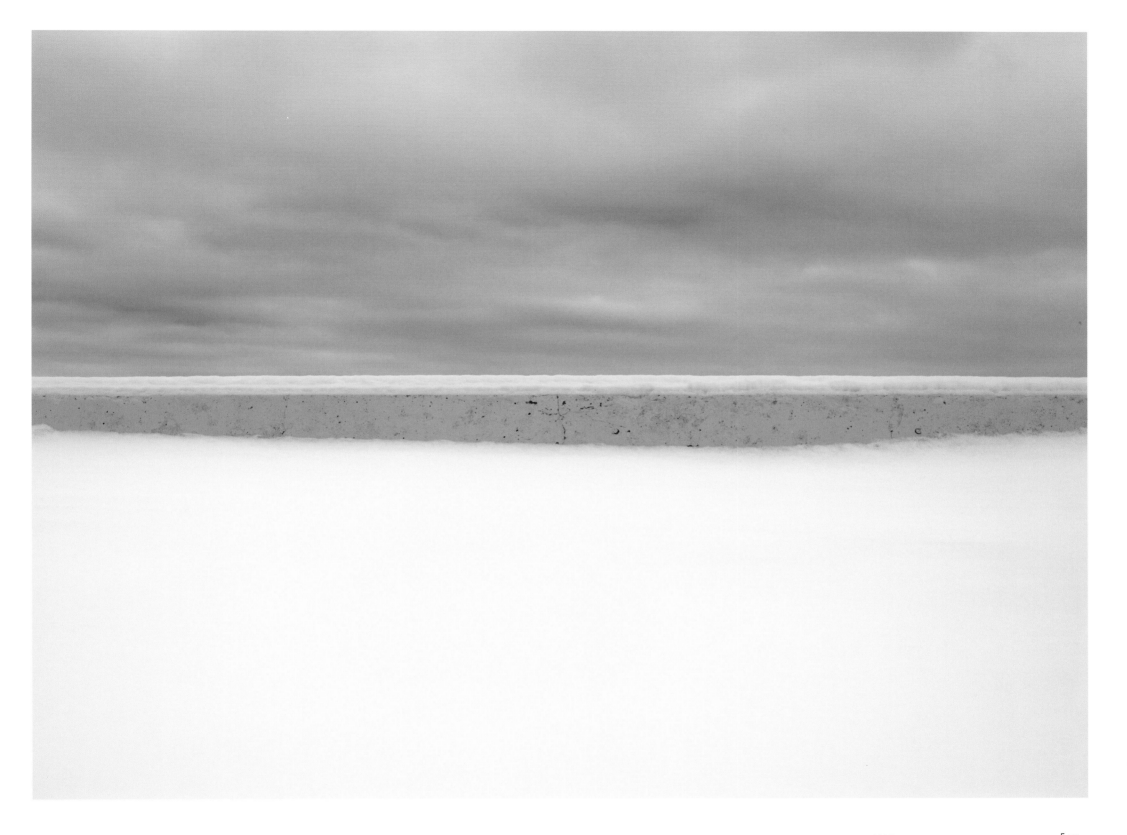

Yellow Berm, 2013

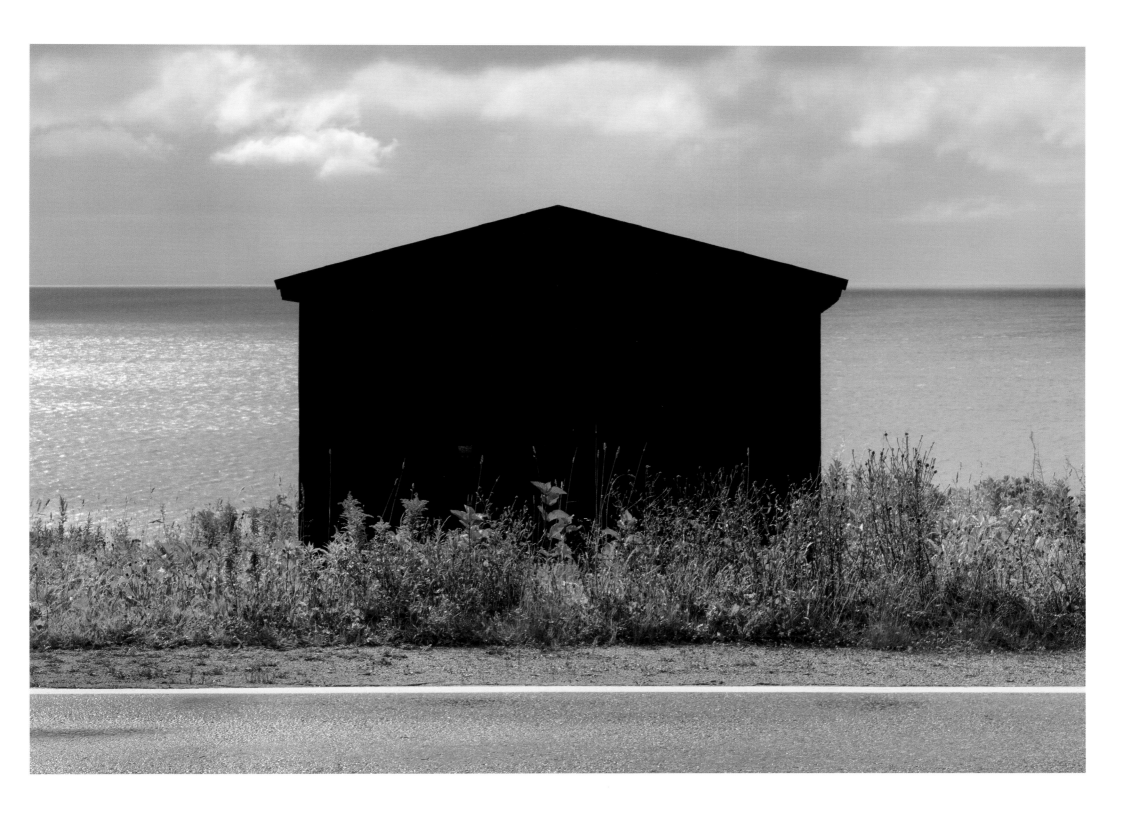

Black Shed, Port-au-Port Peninsula, 2016

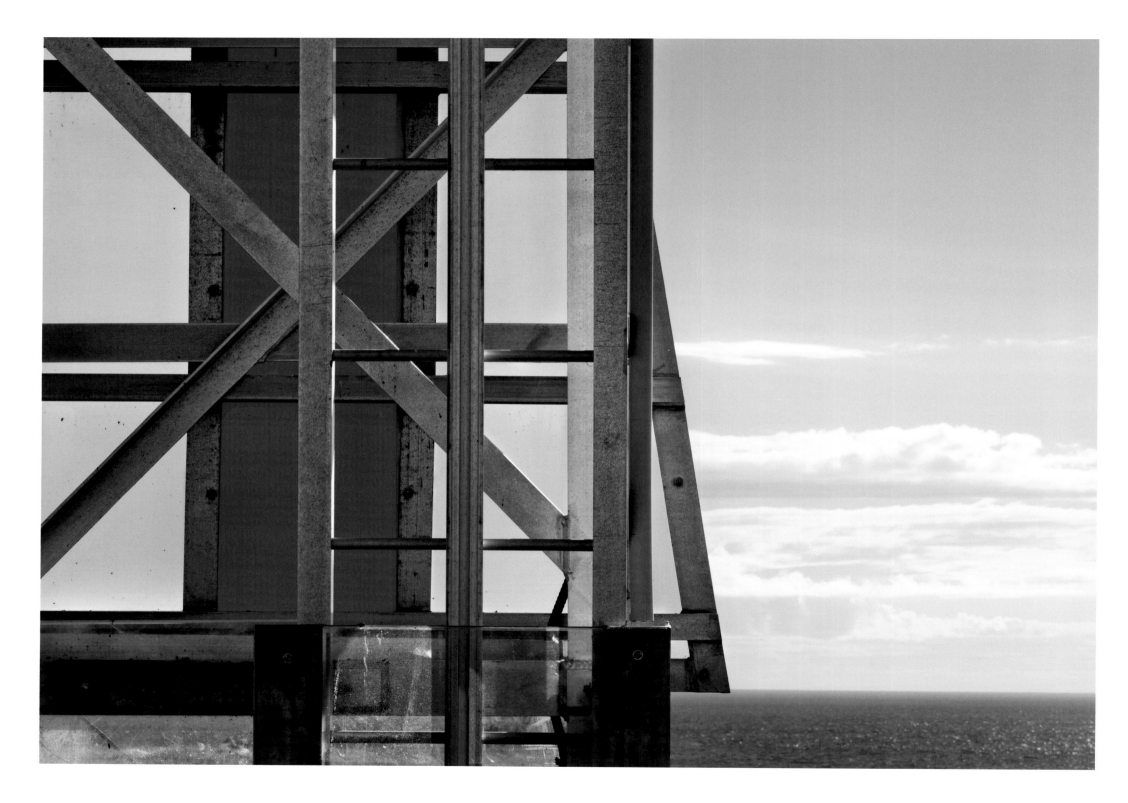

Aid to Navigation, 2016

Ned Pratt's Newfoundland Landscapes

BETWEEN SEA AND SKY

Ray Cronin

There are only three ways to get to Newfoundland—by sea, by air, or by birth. It is a place that can be implacable in its barrenness, and breathtaking in its sublime beauty—usually at once and in the same place. This is the type of land that resists becoming just landscape—human intervention here can't help but feel contingent, transitory. It is hard to leave a mark on such an elemental landscape. Here, the rock is caught between hard places, and it takes hardy people to flourish between ocean and sky, or, as one early colonizer put it, "as near to heaven by sea."

Ned Pratt is a Newfoundlander, and his artistic subject is this island. He has been thinking about Newfoundland—its culture and its spectacular landscape—for most of his career. Newfoundland's tripartite routes of access (by sea, by air, by birth) are all at play in Pratt's landscape photography. Sea, sky, and land (or the land's surrogate, human construction) are all played off against each other in carefully composed images. They are essays in depth—of field, of perception, of conception. The push and pull of foreground and background, so central to the discourse around painting, is present here as well. It resides in the tension between infinite space and solid ground, in the immensity of the sky, wrapping like a bowl over the fragile structures perched on the land, or in the seemingly endless sea, often pictured in its interplay with the sky—fog and mist, where water is captured in the process of becoming air, or air, water.

The enormity of sea and sky, the tenuous rootedness of the human on the land in the face of the sheer power of nature, the contrast between infinite and intimate space—these are the things that Pratt is thinking about in his landscapes. The landscape form has always been a mode

of thinking, although, at root, the landscape is a way of seeing, a way of framing the land into digestible—cogitable—compositions. For humans, the land (and the sea and sky) may as well be infinite, essentially unknowable, and can only be processed on our own cultural terms, whether scientific, religious, or aesthetic. To make sense of them, which really is to seek sense in our presence amid them, is an exercise in bringing them down to our scale. This is what Pratt does in an image such as *Aid to Navigation* (2016, p. 44), where the close-up view of the structure of a range marker makes multiple frames, the illusion of order set against the churning chaos of sea and sky.

His tool is the camera, and he uses the distinctive mode of seeing that the camera imposes to great effect in his work. Framing is central to the way the camera records. It is also a kind of mechanical illustration of the act of seeing: we see everything, but we only really notice what we look at; recognition is intentional, wilful. We limit the world, just as much as we are limited by it. Our physical bodies will never soar as our minds can, but nor can our minds process the vastness of the world, and the torrent of sensory data that constantly inundates us. We must edit, though mostly unconsciously. The camera, with its mechanical (and now digital) lucidity, can make visible not how we physically see, but how we perceive.

Pratt's work is usually undertaken in loose series—themes, perhaps, is a more accurate description—that show his engagement with a particular strain of thought, as expressed by what he sees in the landscape. Always, though, there is the sky, which in its infinity seems to wrap the land in the void. One approach he uses is to find geometry in the landscape, usually in the interplay between structures or objects and the horizon. *Barricado* (2014, p. 47) is an image of a frozen slab of seawater, a ridge formed at the shoreline where the sea meets the beach (while it easily could be taken for a salt-stained retaining wall, the old Newfoundland word used as the title gives away its origins). The sea is a narrow strip, cutting the image in half horizontally; the sky lies beyond. The image at first glance appears perfectly abstract, a study in grey tones. As is common in Pratt's pictures (and in his Newfoundland), the sky is a uniform expanse without form or definition—just a

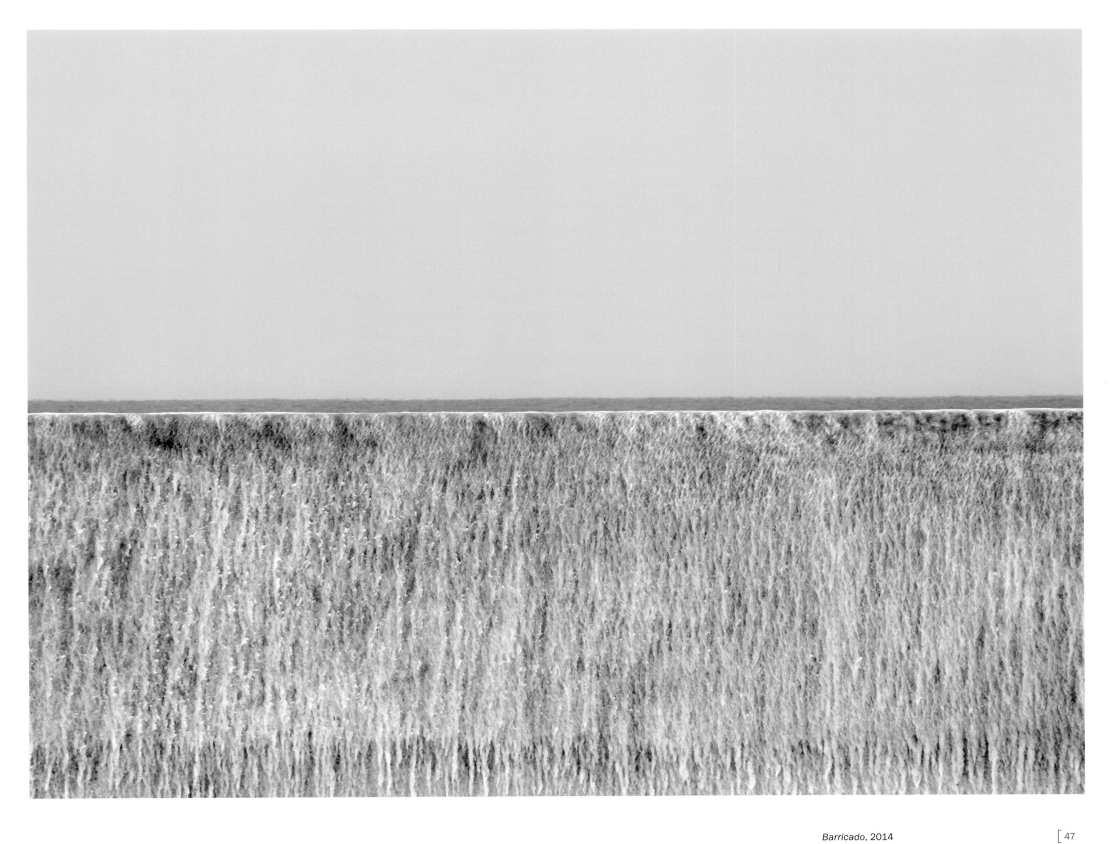

Barricado, 2014

grey, misty field stretching seemingly forever. The sea is a single dark emphatic line, pulsing with quiet power. And the ice wall, the barricado sits right at the forefront of the picture plane, a solid mass rooted, if only temporarily, to the earth. In looking at the image, we are projected back and forth between the infinite distance of the sky and the whiplash abruptness of the ice ridge, marked with striations that suggest marble, or flowing water, or, frankly, paint, as if an Yves Gaucher canvas has been actualized, incorporated into the landscape.

One is often reminded of paintings in looking at Ned Pratt's work, but far fewer of them feel like the work of his father, Christopher, than one may have been led to expect. For me, Ned Pratt's use of geometry to temper the infinite spaces of the sublime, to turn the mundane into the symbolically freighted, is a tenet of classicism, and the epitome in Canadian art is another painter, Alex Colville. But Pratt's landscapes also veer toward abstraction, as noted by critic Mary MacDonald: "Water, earth, and sky become formal elements that talk to one another. It's a conversation about surface and balance rather than place (despite some of the titles giving away their locations)."[1]

In *Harbour Entrance* (2015, p. 39), Pratt's geometry is near perfect—the picture is divided horizontally, the top half the light grey void of the sky, the lower half evenly bisected into two squares: a slice of dark grey retaining wall on one side, the medium grey ocean stretching away in the distance on the other. Initially, as with all of his geometric photographs, the image appears flat, a colour field. But when we recognize the image, we create, ourselves, the sense of immensity. We are whipsawed back and forth between foreground and background, perceptually, launching us into space even as we are rooted to the ground. Where Colville uses geometry to impose order on chaos, to stabilize the slippage that seems to attend all human beings in the world, Pratt's geometry, despite its rigid precision, destabilizes us, tips us towards the void. What anchors us, finally, is the actuality of the image—the fact that it is a photograph and not a representation, and that we recognize it, eventually, as real. The void, the abyss, the sublime exist in our perception, but the actuality of the world, for all its indifference to our existence, sustains us.

The tenuousness of our presence is expressed in Pratt's treatment of buildings in the landscape. Where in Colville (and in Christopher Pratt's work) structures convey solidity and abiding human presence, in Ned Pratt's photographs, the buildings seem as ephemeral as soap bubbles—perched tenuously, emphatically temporary. They stand, for the moment, but there is little sense that they will endure. Pratt portrays the landscape bodily—projecting the sense of physically occupying the spaces he captures. Buildings stand in for figures, awkwardly inhabiting the land.

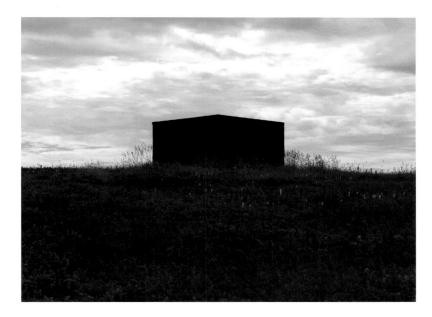

In *Backlit Structure* (2016), the viewpoint is from the bottom of a slope, looking up at the crest of the hill. A building, a rough wooden structure, a barn or shed perhaps, sits just beyond and below the apex of the hill, rising out of the grass, with the vast expanse of sky beyond it. The picture is evenly divided horizontally, half sky, half land, with the building occupying the centre—the focal point, as it were. The composition's upward progress lightens the structure, as if it is floating. In *Pack Ice, Northern Peninsula* (2016, p. 51), the composition is in thirds—snow covered land, ice covered sea, and cloud covered sky. The land and sky take up the bulk of the composition, with a narrow, horizontal strip occupied by a small shed and with the pack ice as its background. The roofline completes the horizon line, and, again, the swell of the land cuts off the shed, hiding its foundation. It also could be floating, though the visual feel of this work is of compression—as if the lowering sky is going to meet the rising land and crush the fragile construct of weathered wood. It is an utterly static image, yet Pratt manages to communicate the sense of weight and movement of pack ice, the swelling rise and fall, using as his surrogates the land and sky. In *Fog Horn Shelter* (2015, p. 76), our viewpoint is aerial, soaring

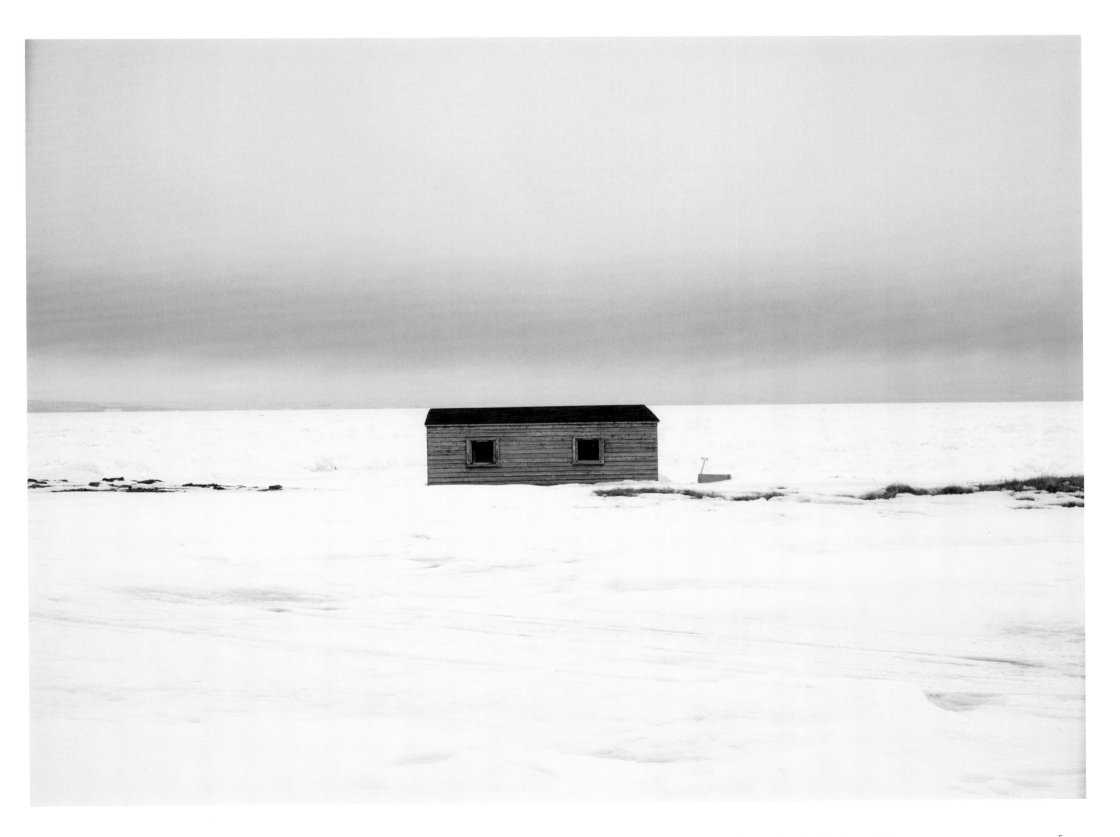

Pack Ice, Northern Peninsula, 2016

over a small building that sits at the bottom of the image, rooted, again shown without any sense of its relationship to the land. If, as Gaston Bachelard contends in *The Poetics of Space*, immensity is a philosophical category of daydream,[2] this image is a flying dream—one with seemingly infinite lift—the building acting as a diving board or launching platform. There is no sense of compression here; rather, the eye soars, along with the imagination.

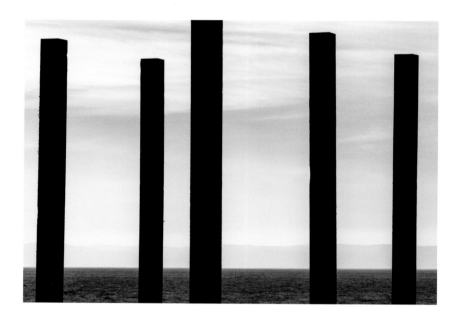

There is a distinct emotional charge in Pratt's pictures—exaltation and depression, awe and humour, resignation and defiance. *Miller Mechanical, Trinity Bay* (2008, p. 15), a simple image with a wooden power pole vertically bisecting what is otherwise just sea and sky, might be the most personal of them all—figurative even. The small metal plate affixed to the pole, with a serial number, could stand in for a name, I suppose, or a set of coordinates. It is both familiar and strange at once, and its slight lean serves to provide a sense of movement, enhancing the figurative feel of the image. A new work, *New Wharf, Early Cribbing* (2017), steps away from the solitariness of so much of Pratt's work. Again, we have sea and sky, the dividing line of the horizon so important to the image's impact. Five square wooden posts occupy the foreground of this image—one stretching from top to bottom, with two on each side that do not reach as high as the top of the picture. Figures once more, but a group this time, perhaps a family.

Geometry, lines of division and opposition, these tools are used by Pratt to convey emotion and poetry. He uses geometry, whether found or imposed, to plot images that communicate the sense of being in Newfoundland, on that land, buffeted and cradled, between sea and sky. His work relates to architecture and to painting; he reflects upon place, and, most of all, upon his place in the world.

The last image I want to talk about, *Jet* (2015, p. 55), depicts just sea and sky. As viewers we are rootless in this one, projecting ourselves, perhaps, onto that jet whose contrail slices across the clouds. The way the image is framed, with the contrail crossing a cloud bank, the contrasting greys of the clouds at the horizon, the lighter space delineated by the jet's trace and the high clouds, creates a near perfect image of a building—a fish shed, or a low house, as simple and earnest as a child's drawing. Here is that conversation between earth, sea, and sky, and here too is an image of intimate immensity.

In Ned Pratt's images, Newfoundland is not only a rock between hard places, but also that philosophical daydream of home, a place in all the richness of the word: home, site, culture, history, and more. Humans may only temporarily mark this landscape, but as Pratt's work makes clear, the place leaves its mark on its people in a lasting way.

This essay was originally commissioned by Prefix ICA for *Prefix Photo* 38 (Fall/Winter 2018) and has been edited for this publication.

1. Mary MacDonald, "Poetic Heroic Horizons: Mary MacDonald on Ned Pratt's New Exhibit," *The Overcast*, 1 June 2016.

2. Gaston Bachelard, "Intimate Immensity," *The Poetics of Space*, translated by Marie Jolas (Boston: Beacon Press, 1969), 183.

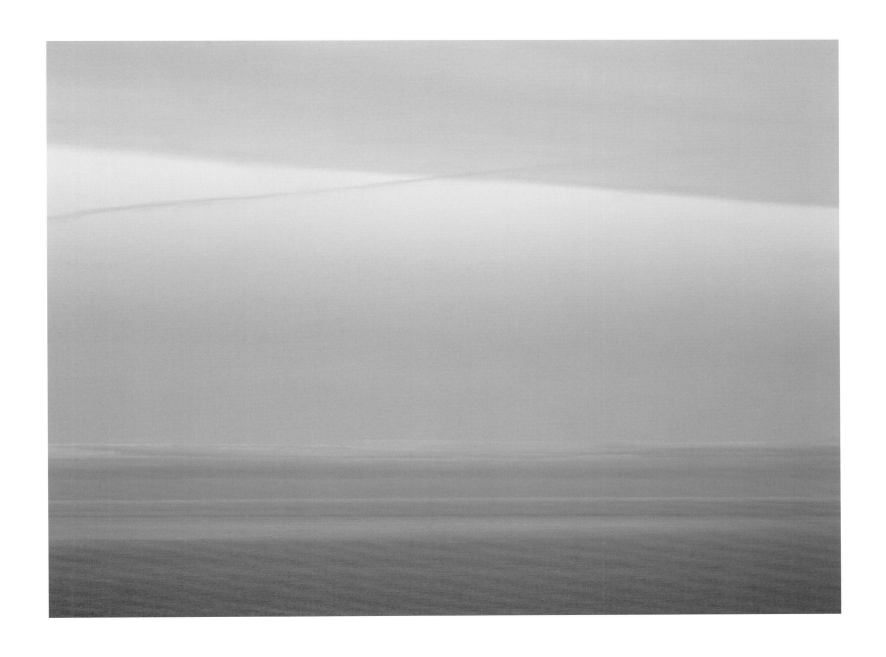

Jet, 2015

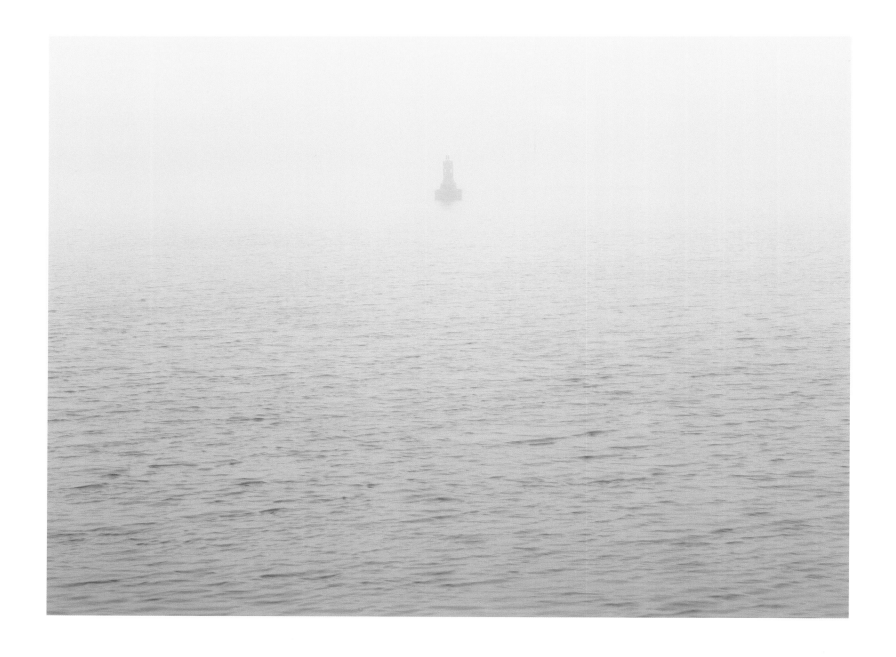

Starboard Buoy, 2016

Ned Pratt's Newfoundland

SOMETHING BIG, SOMETHING SMALL

Jonathan Shaughnessy

"There used to be a huge caribou herd out here. Thousands of animals and now they think it is down to probably around a hundred, from brain worm—a parasite they get off the grass from snails and things like that," says Ned Pratt as we come upon the barrens near the southern tip of the Avalon Peninsula. It is a vast swath of mossy plains and arid rock dotted by peat-lined patches of water, the longer stretches of which can sometimes offer up brook trout to anglers. We have just passed the municipality of St. Vincent's–St. Stephen's–Peter's River, where Route 90 turns to Route 10, the Southern Shore Highway. It follows an abundance of grey-pebbled beach that divides the North Atlantic from Holyrood Pond, a brackish body of water that is said to contain land-locked cod. "I don't know how edible it is," says Pratt. The view from this section of the Irish Loop Drive as it descends down to sea level at The Flats is stunning—and somewhat rare: "It can be foggy down here for weeks on end. When the wind starts coming out of the southeast, there's a permanent fog bank out there, and it'll blow in.... There's a certain amount of luck to days like this."

He needs that characteristic fog to produce a new photograph that he has had in mind at this location—one that he has not yet been able to capture. The photo is to be of a wave, ideally above 1.2 metres and about to crest, staged with sky above and beach below, through lines so faint as to be nearly indistinguishable. He achieved this effect under calmer seas in *Starboard Buoy* (2016, facing page), where the blue of the water and that of the sky nearly meld into one. For that image and

for this one, he needs the fog: "Just so much fog that it's not sentimental and also so that you can isolate a single wave. I want it to be so foggy that you see only one thing come out of the fog. It's just beautiful right now — absolutely useless!"

Waiting for the exact conditions to surface within the landscape is a habitual condition for Pratt. He employs his camera as a vehicle to record what it sees, with the caveat that his focus be only on certain things—for the most part, objects of human fabrication that he finds incongruous with their surroundings—framed in distinctly particular ways. The formative work that pointed the direction of things to come about a decade ago was *Miller Mechanical, Trinity Bay* (2008, p. 15), Pratt's image of a slightly weathered wooden pole set indeterminately against the calm ocean. "I was out with my camera trying to do landscape work and getting totally frustrated because I was seeing my history all around me, and nothing caught my interest," Pratt recalls of taking the photo. "Then I saw this pole . . . and all of a sudden it made sense. I should photograph this and just concentrate on the textures on this simple thing. I was still using film then and the Polaroid came out, and I just thought it was absolutely beautiful—the way that luck formed this band of light that gets fatter in the middle of the pole, which I could adjust to a certain extent. The centre of the pole is off—it's not perfect. It all balances out and is beautiful despite itself. Somehow or other it's a horribly ugly, beautiful thing."

Pratt's search for beauty in spite of itself has resulted in a comprehensive and continually developing oeuvre, fortified most recently by one of his most deceptively complex offerings, *Cape Norman Lighthouse* (2017, p. 59): a study of angular compromises between an imperfect structure and (always) perfectly straight horizon. It is an image titled after a place but with no obvious relation to it. All of Pratt's photographs fall in line with the minimalist, abstract ethos evoked here and elsewhere, for example in *Below a Drift* (2017, p. 27). The work as a whole presents a liquidation of sorts: a divestment of the image from habitual sensibilities, personal nostalgias, and/or stereotypes of place in the face of settings all but preordained to provoke just that. For Pratt these are the vistas of Newfoundland, the land in which he grew up and a place that, for him, is already loaded with

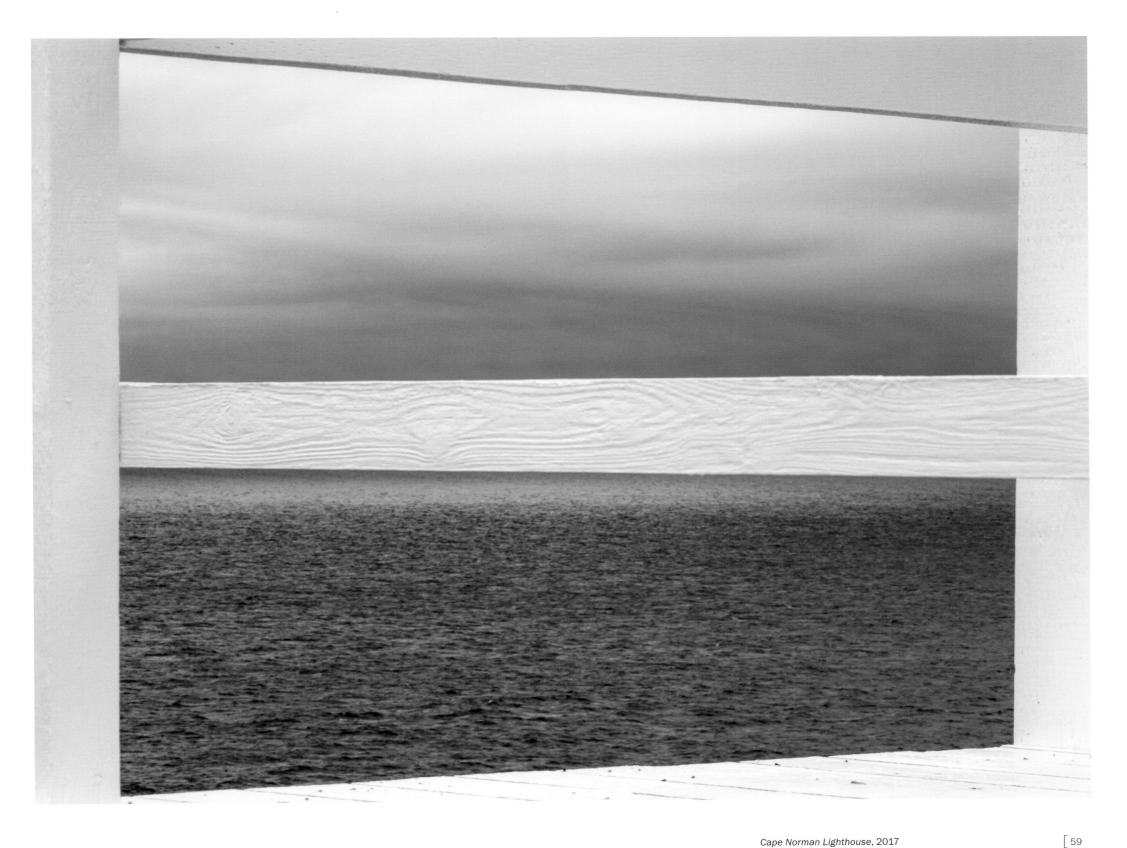

Cape Norman Lighthouse, 2017

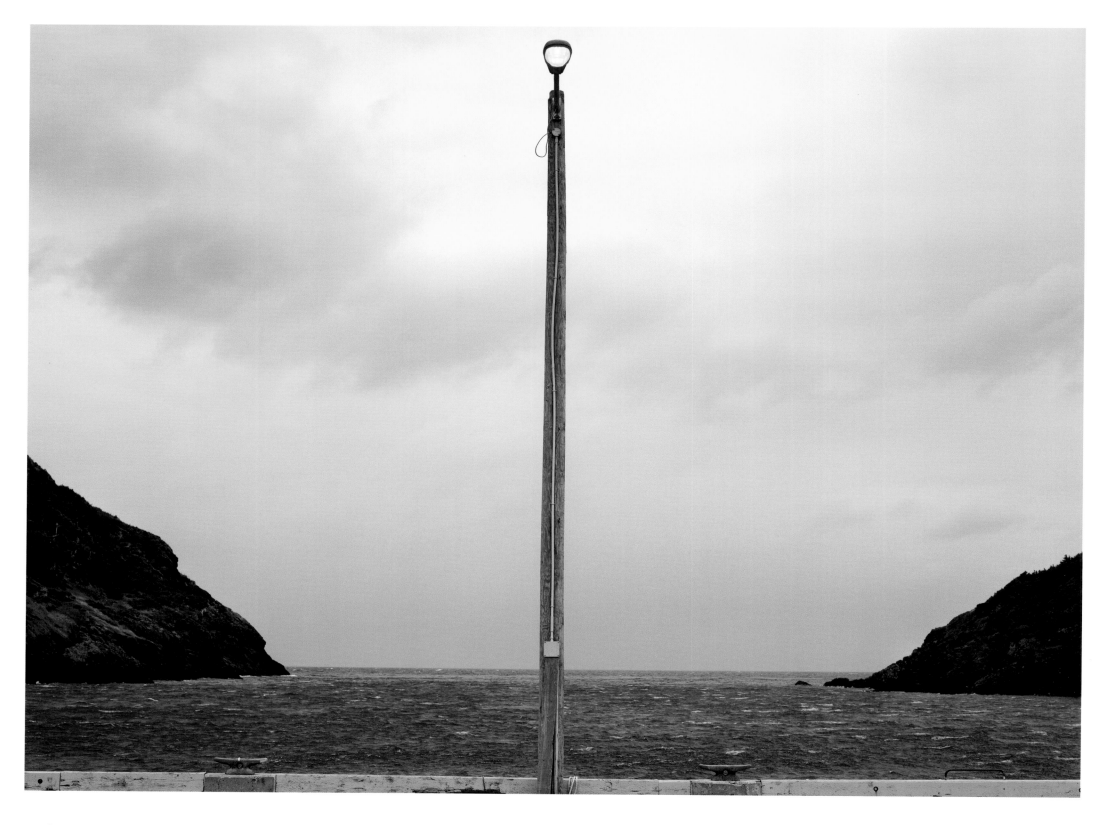

End of the Wharf, Little Harbour, 2017

associations forged at the hands of marketers and tourism boards, as much as by the ideas and representations of storied artists who have come before. And, perhaps most importantly, are his own memories, experiences, and projections, infused with measures of all of the above. "You're always seeing the stereotypical Newfoundland, all the time," he says. "It's like eating something that's too rich or something, it's frustrating. . . . There are many times I say I can't do that. There are so many places I can't go."

There are, however, places that Pratt most decidedly can and does go, as articulated in his concise photographic repertoire that, while it aims to aesthetically detach from the landscape in a bid to "destroy the first impression and rebuild it at the same time into a different kind of beauty," is also deeply connected to and entrenched within it. Why else call a wooden light post flanked by two hills leading down to the shoreline *End of the Wharf, Little Harbour* (2017), or a thin yellowish plank that divides the frame *Connaigre Peninsula* (2015). There is also the puzzling perspective of woodpiles and young evergreens under grey sky in *Ruby Lumber Company* (2017, p. 63), and the deceptively simple composition of a red ball and wire facing light cloud and blue sky in *Radar Reflector, Port au Choix* (2017, p. 65). Of

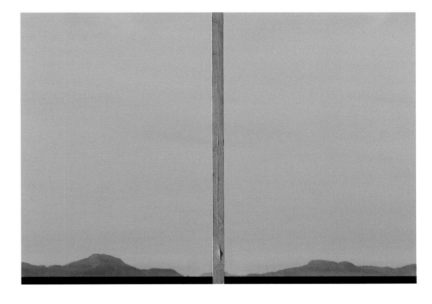

the latter, Pratt comments, "I am basically looking up into the sky. I'm about 45 degrees to it, maybe less, and so that is actually a set of three wires that are going back and forth, and the ball is rotating. So the wires are going back and forth, but there are six bolts on the ball that had to be in just that spot as the ball is rotating. And the wires had to line up, so it just seemed like one wire bleeding off into two. And then, of course, the sky has to work as well, so it's actually a lot trickier than you think it is."

Ruby Lumber Company, 2017

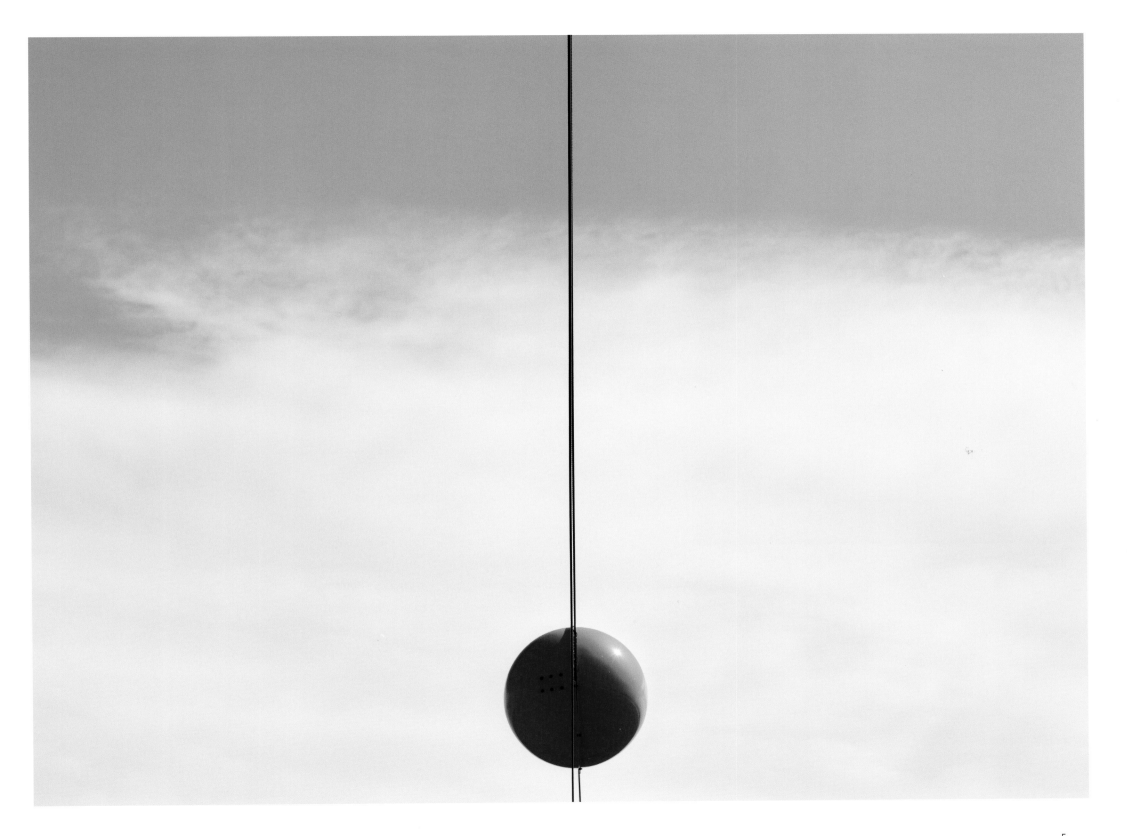

Radar Reflector, Port au Choix, 2017

All is trickier than it seems in a Ned Pratt photograph for the simple reason that there are very few tricks to it. Migrating from a field camera to a digital Hasselblad years ago, Pratt adheres to a photographic ethos whereby he will only allow certain corrections and edits in the process after taking the original image: "I let myself crop, because you can't crop accurately enough in the camera.

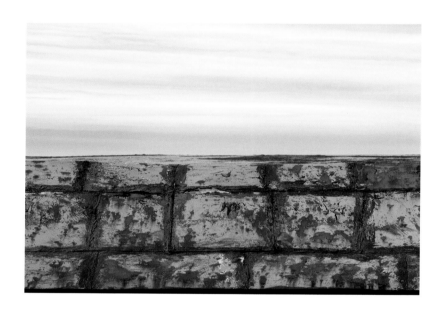

So I'll crop and I'll fix parallax, because sometimes you just can't physically get in the right spot....I don't take things out and I don't put things in, as tempting as that is, and I take out dust and that kind of thing. If I could do it in the darkroom, then I'll do it...like you had to [when working in the darkroom] take dust marks out, and even when you were printing you could change perspective by tilting the easel...but then you'd need good depth of field on your lens to keep everything in focus."

As for the actual time spent in situ waiting for the variables he is seeking for the photograph to emerge in the landscape, Pratt comments, "You can only have so many controls....When I used to use a field camera or a rail camera...you could control perspectives, you could control parallax, you could flatten images out, raise them, lower them without having to be on a ladder. You could change the relationship with a lens to your film plane. You can't do that with a Hasselblad, so it has to be with height, the height of the camera, tilt, the tilt of the lens, and the turn of the camera body—or swivel or something—and so those are really only three motions that I have. And distance. I get closer, get farther away, up, down, you know...and stopping in the right place, but being incredibly picky about where you stop!"

Barren Cabin, Tin Roof, 2015

Maintaining an integrity of place within photographs that otherwise seem to offer means of estrangement from where one is, and always has been, defines a tension running throughout Pratt's work. It is the key ingredient that makes the small parcel of ocean in *Aid to Navigation* (2016, p. 44), for example, or the cabin rooftop set against the horizon in *Barren Cabin, Tin Roof* (2015, p. 66), or again, the barely legible slice of land dividing a vastness of pond, ocean, and sky in *Barachois, Brackish Water* (2013, p. 69), neither purely formal conceits nor canned sentimental affectations. There is something else going on, the product of a way of seeing that would only be tested, perhaps, if Pratt were to try what he does somewhere else entirely.

"These simple photographs are made from a place that I know so well that in a way I have a right to do it because I'm talking about my pasts, my history. If I take this same approach—because everything is an approach—and apply it to a place where I have no history, like the Prairies, are they then just designs? Are they not about anything because I have no connection to the place? So then all of a sudden the backbone of the work is gone," he explains. "I can see doing work maybe up in Northern Alberta, Fort Mac, where there're so many Newfoundlanders. There's justification there…and I think I could feel at peace working in a place like Yorkshire, where my family comes from. As long as there is some relationship to me that I can justify, and even then I am wondering if I am pushing it. There has to be some relationship to place."

St. Vincent's, the beach where we stand to discuss the wave photograph that remains only a concept, is one place Pratt knows especially well. "We would come down here and watch storms when we were kids and the waves would sort of break over [the fencing separating the roadway from the shoreline] and the road would get covered with beach stones and you'd have to get it all cleared off again." The municipality of just over three hundred people stands between Salmonier Line, where Pratt grew up and where his father, the painter Christopher Pratt, continues to live, and Cape Pine, a remote enclave about an hour's drive from St. Vincent's and just a short jaunt away from the nearest

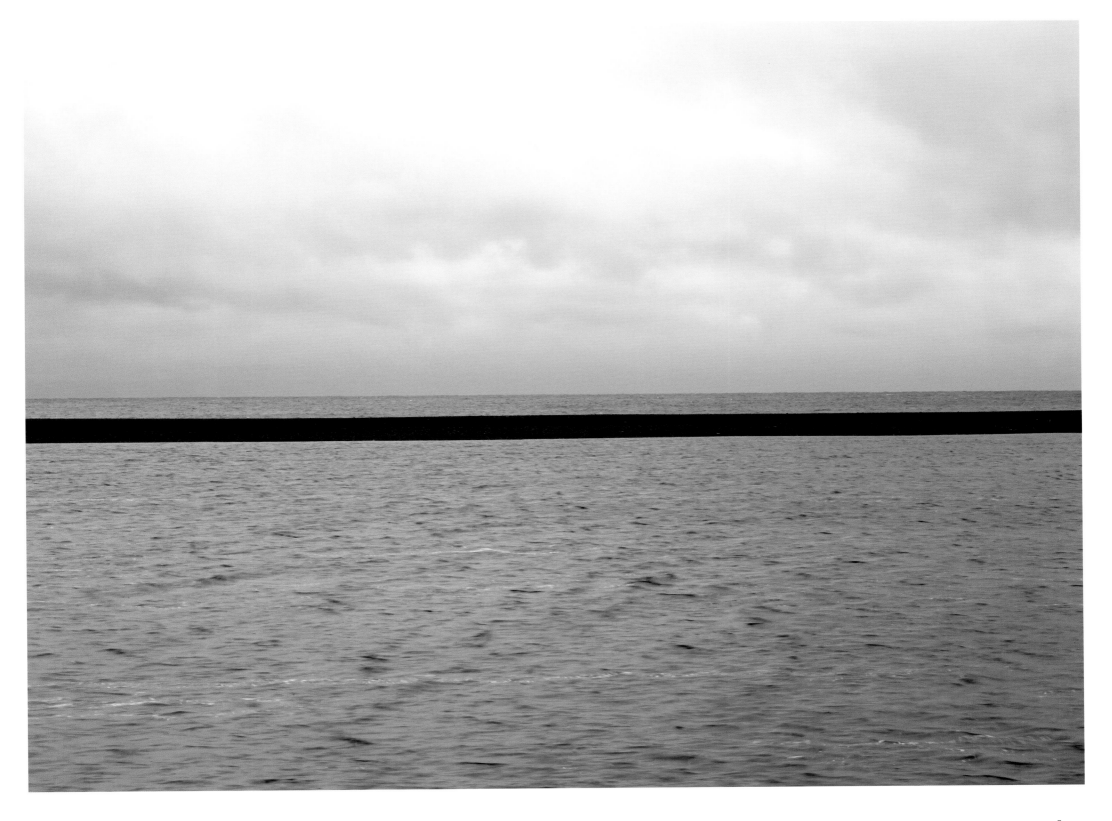

Barachois, Brackish Water, 2013

town, St. Shott's, a community of less than eighty inhabitants located to the west of Trepassey Bay. Cape Pine is a National Historic Site, home to a 15-metre-tall lighthouse that since 1851 has guided ships away from rocky shores toward the Cabot Strait and onward to the Gulf of St. Lawrence. It is also a place where Pratt goes to get away from St. John's, and it brackets to the south a region of the Avalon Peninsula that the prominent Newfoundland photographer calls "his spot."

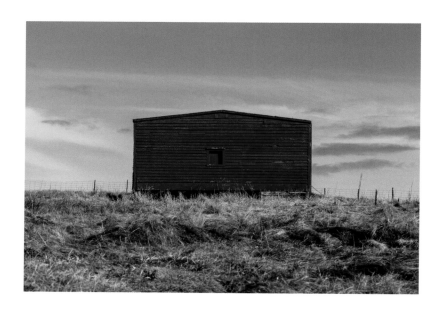

Many of the photographs already discussed come from the area, as well as recent explorations such as *Outbuilding, St. Shott's* (2017), and *Fog Bank at Cape Race* (2017, p. 33). "I get happier and happier the further down this road I go," Pratt says as we get ready to stop in St. Mary's en route to St. Vincent's, then onward to Cape Pine. The long gravel road off Route 10 that reaches Cape Pine has also been subject to Pratt's lens, in the staidly atmospheric *Cape Pine, Early Morning* (2017, p. 73), for example, which breaks the barren setting articulated within the frame into three bands. A near-geometrically shaped expanse of water the colour of the sky stabilizes the middle plane, and balances the overall composition better. In this case, it again took the fog to bring it together and blur the transitions between the various planes of the image. But Pratt cannot always find the weather conditions he's looking for. "In the summertime out here," explains Pratt, "you have these beautiful nights where you're out of the house and it's dead calm and stars are everywhere, and the whales are in and feeding up close to the shore, and you can hear them. You can hear the whales—breathing, you know—you'll be sitting out on the deck listening, and it's so quiet that it hurts, and you'll hear the whales just down over the cliff."

Outbuilding, St. Shott's, 2017

The cliff at Cape Pine is there also in Pratt's corpus, sort of. It is what is missing from view in *Guy Wires* (2014, p. 75), in which three cables supporting the radio tower next to the historic lighthouse pierce an otherwise picturesque scene of pristine ocean, save for a small buoy floating at the bottom of the frame. It is hard to infer exactly where water, sky, and/or cloud connect in the image, and this is undoubtedly the desired effect as four bands of uneven widths divide the photograph like a monochromatic painting in blues. Pratt's debt to abstract traditions looms large here, and flatness presides, as it does throughout the work. But then there's that buoy, an iconic reference to "ocean life" if there ever was one. "I'm still not sure if I made the right decision going with that. I like the ridiculousness of it, and again, I keep going on about defacing or undermining, but really without the wires you have a very traditional, minimal, Newfoundland image. The wires ruin it but also make it something, I think, much more interesting. My original idea of putting it in to sort of ruin something that was beautiful is why I did it. It's there on the edge."

A photograph such as *Fog Horn Shelter* (2015, p. 76) is also "on the edge" of beauty, "defaced" only by the fact that the shed itself does not have a ground of any kind—it teeters on an oceanic precipice that is more or less entirely still. Pratt's use of an all-over focus is apparent here—a near impossible achievement given the vastness of the subject. I ask if the goal is always to keep the focus of an image as even as possible throughout the picture plane. "Yes. Depth of field is a device, you know. When you have intensely short depth of field it creates a strange sensation that you are looking at a toy or what you are looking at isn't real," he says. "Sometimes I'll drop the foreground out of focus so it turns into an abstraction, and sometimes you just can't get the composition you want and have everything in focus—it's just impossible. So then you have got to decide where you're going to put what's out of focus. But you can use it, I mean, depth of field can really be a bit of a trick—I consider it a device that you should use sparingly. I think the photograph should be as sharp everywhere as it can be because then it's one less thing…a variable you're taking out of it. And another thing that is a device is exposure time. Long exposure times will give you blurred motions. If it's really subtle that's okay, but once you use the overdramatic motion, that becomes sentimental."

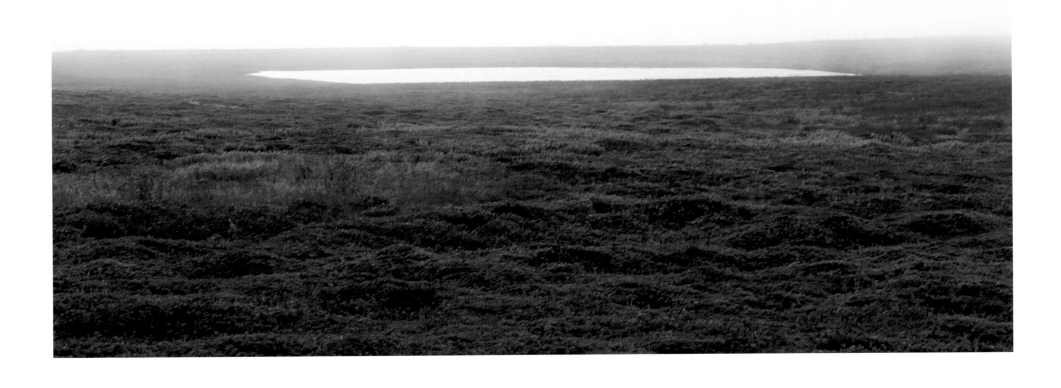

Cape Pine, Early Morning, 2017

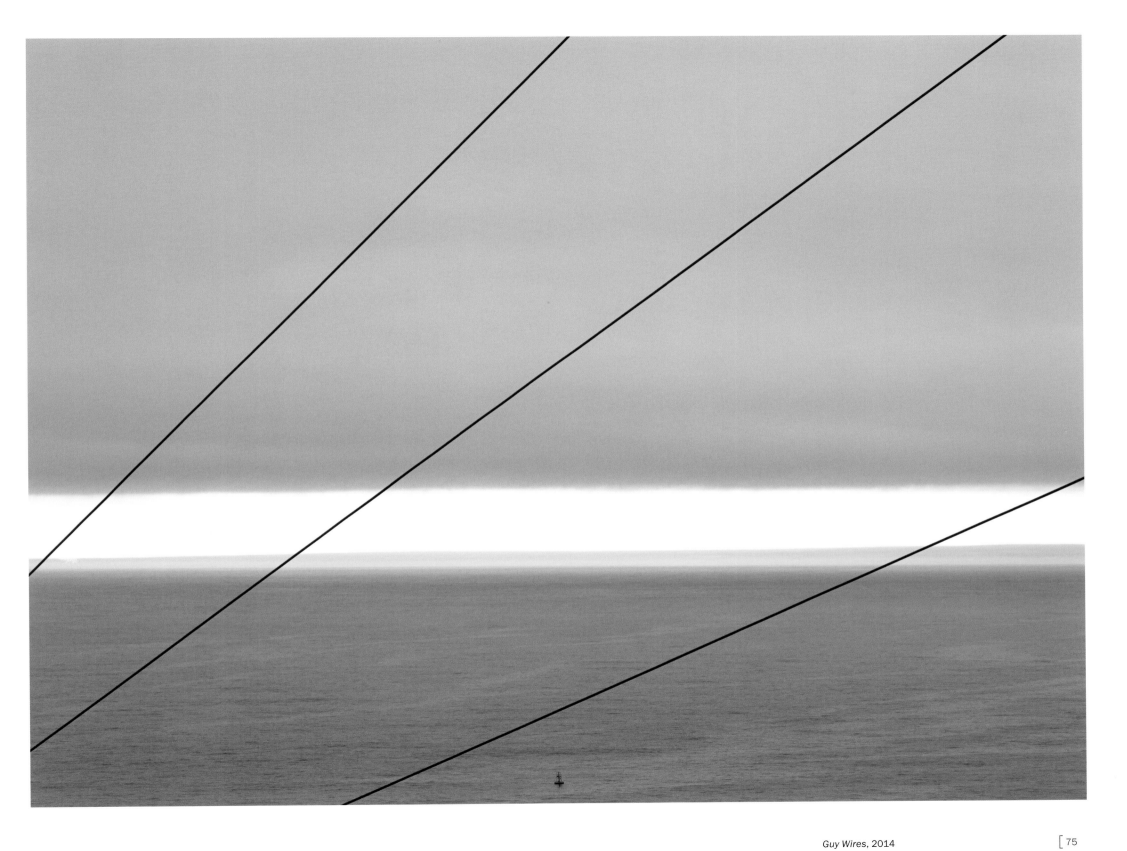

Guy Wires, 2014

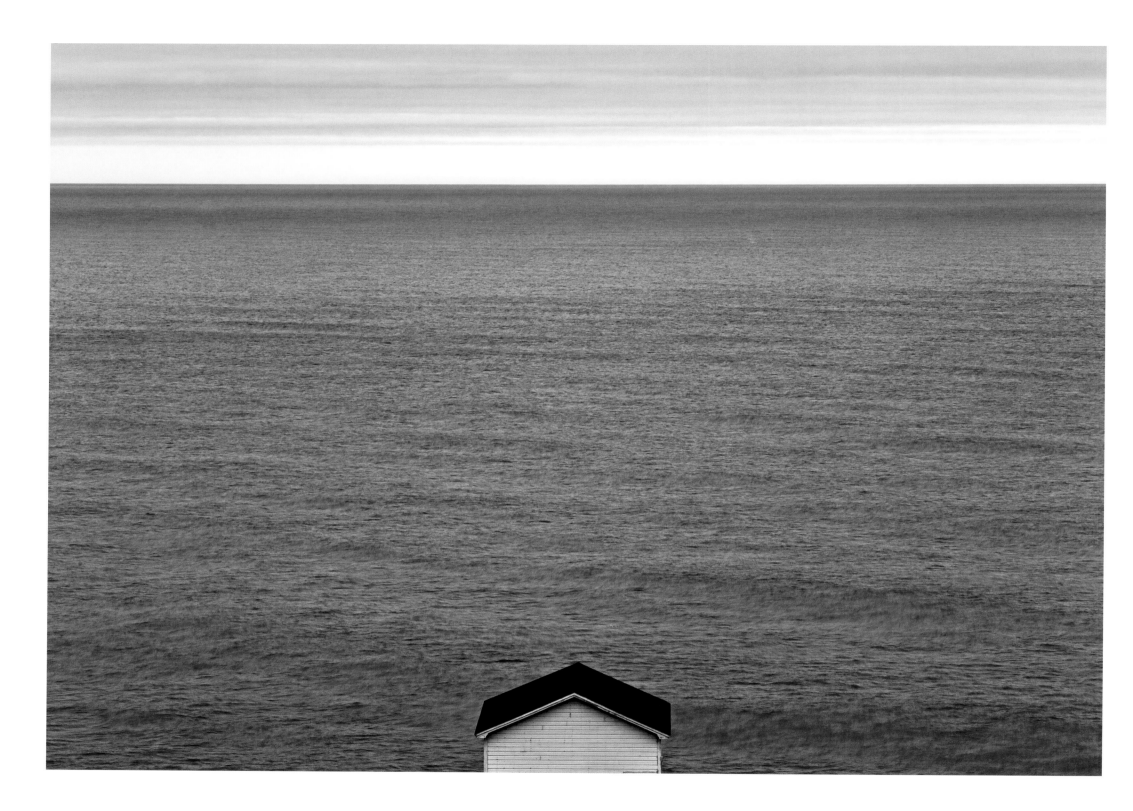

Fog Horn Shelter, 2015

If there is to be no sentimentality in Ned Pratt's Newfoundland, the same does not hold for the sublime. The latter was a subject emphasized in an insightful review of the artist's work by Sky Gooden in 2016. The Toronto-based critic wrote eloquently how "in Pratt's pictures, within the silent bracketing of space that a ridge of snow, a strip of wood, or a sea-level horizon can provide, there lies an enervating allusion to nature's abysm. His control is constant, though he grips something boundless."[1] Pratt identifies with the sublime as an idea, though not exactly in the sense that art history has come to define it through Romanticism. "I think the term sublime—when and if it can be applied to the work—is a good thing. The mundane becoming the sublime is an accomplishment. That's successful. I don't associate something being sublime with something being romantic. I think the sublime is something dangerous and threatening." It is also a feeling that he readily assigns to many of the formal relationships that adhere within the work, no more so than in the aforementioned *Fog Horn Shelter*, which pits an isolated cabin against something much larger, indefinable, and unwieldy.

Pratt speaks about the fascinating manner in which the sublime as disquiet manifests for him into image: "There's a fear that my mother [Mary Pratt] and I—a dream that we both have—about something very big and something very small—a sort of tension that I think about in my photography," he explains while grabbing a piece of paper to make a simple explanatory drawing. "Say that you had a massive sphere that is weighty and you had a pin—tiny, desperately sharp—this proximity of the mass and the fine point is where there is a real feeling of threat, when you have something massive and something tiny coming together. Right when they are about to touch is when you wake up and you don't see it happen. But there's this tension between a strong and a weak form. Somehow or other the weak form is always going to prevail over the massive form, and it doesn't make any sense." He reads from a page of notes about his "something big, something small dream":

More than simple shapes pushing against each other, it's about the force of proximity, like two magnets of opposing poles being pushed toward each other

but never touching without releasing some great force that never happens. It's the tension of refined proximity; that minuscule vibration caused by the proximity [that] forms an unknown interest.

Such incongruous proximities appear in Pratt's photographs not only at the level of the overall image but in every corner of the work and specific parts in between. One exceptional example is *Modern Architecture, Fogo* (2015, facing page), in which a wall of darkly stained wooden siding juts across the horizon line, creating an intricate battle between foreground and background to the lower right-hand side of the image as object and ocean "meet." This dance between two forms overtakes what, in a more stereotypical shot of the ocean, would likely have been promoted to centre stage: an iceberg and cliffy hillside dwarfed on the lower left of the frame. We "know" that the latter are far in the distance, but the jutting wall thwarts any attempt at a vanishing perspective. Indeed, the vernacularly inspired modern architecture claims the image and secures for it a residual flatness—that the angled slats read as flat to begin with is remarkable. "As soon as you have a vanishing point, you have a depth that you can't get away from," Pratt asserts. "I try to keep vanishing points off to the sides as opposed to in the photograph because it gives me the flatness. Depth is sentimental because it makes you think of the place more, whereas when you just have a wall of image you're not quite as invested in where it is.... Vanishing points also create motion, and command where your eye goes. Without a vanishing point your eye can sort of swim around the flat surface of the image."

By extension, the temptation towards distance is also resisted in Pratt's numerous photographs involving roads. *Guardrail* (2009, p. 31) spends unqualified time with an otherwise innocuous guardrail on the side of a highway being slowly overgrown by weeds. In *Trailer with a Red Stripe* (2011, p. 23), perhaps one of Pratt's best-known early images, the red of the trailer couples with the thin band of yellow on the road below. In each case, the orientation is horizontal; the asphalt surfaces are photographed always "as a band." *Lay-By, Wreckhouse* (2016, p. 80) tests this consistency in a

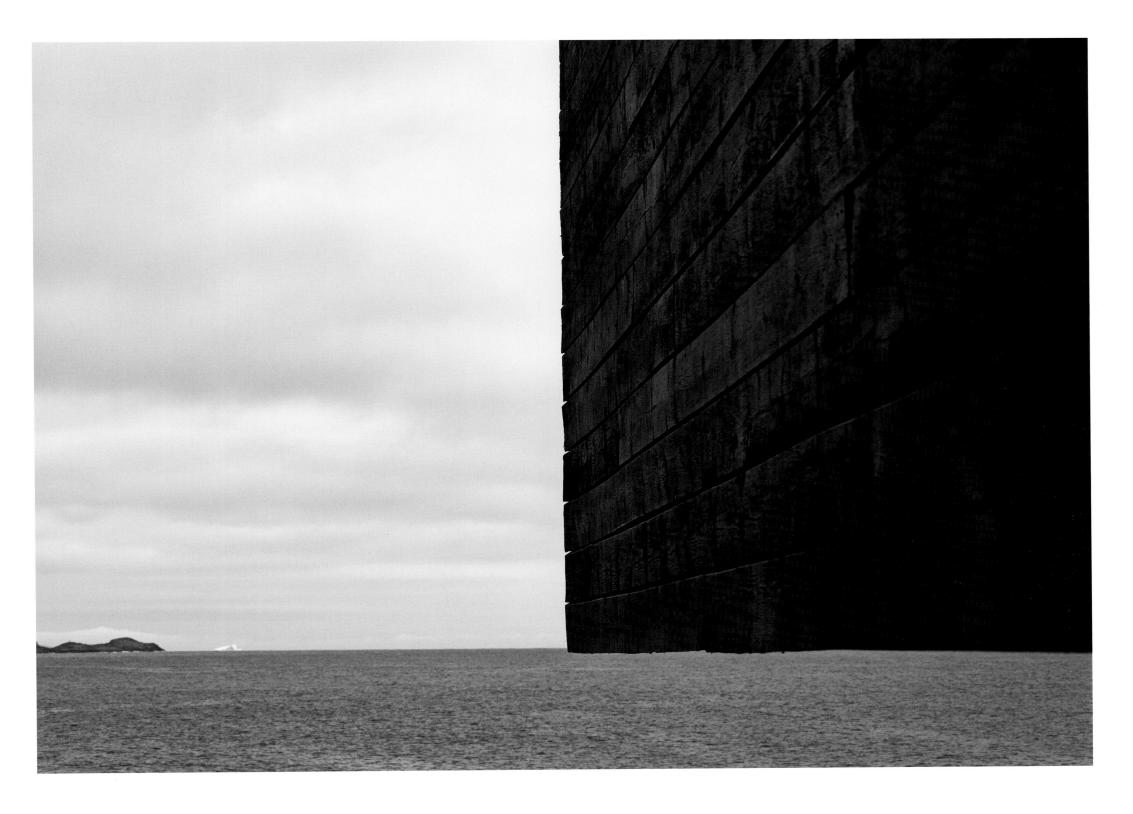

Modern Architecture, Fogo, 2015

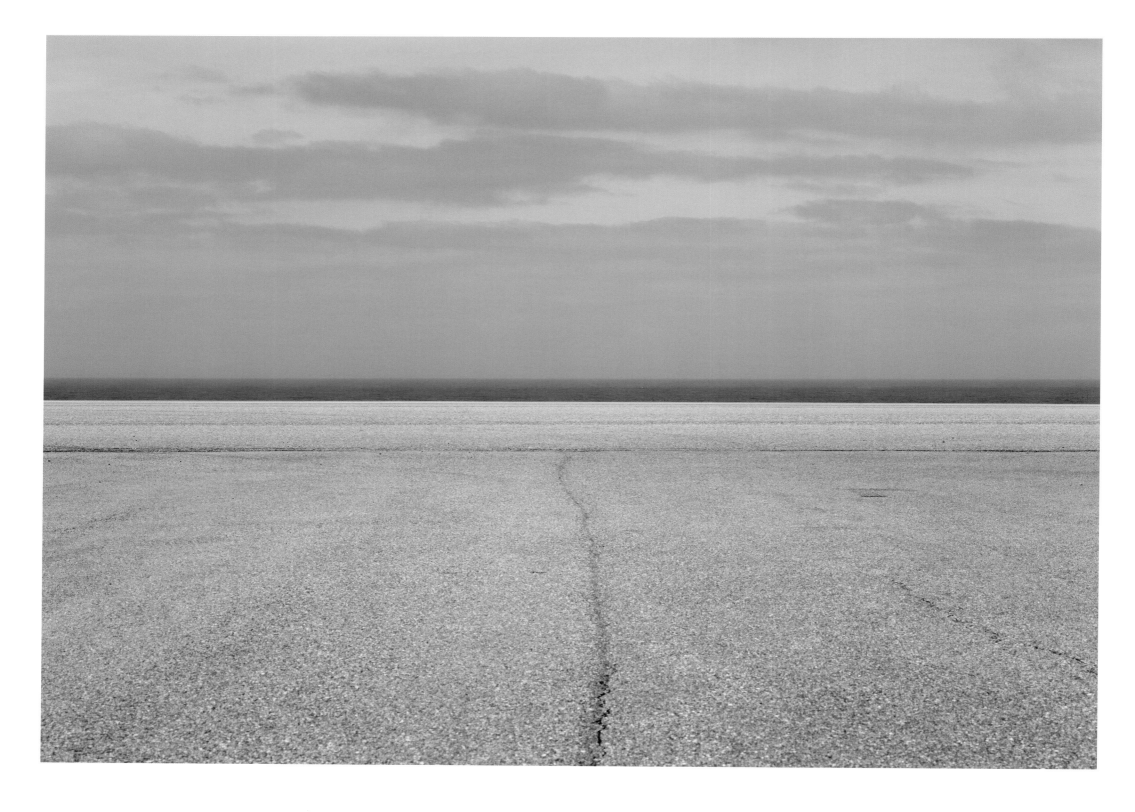

Lay-By, Wreckhouse, 2016

tantalizing manner. Cracks in the surface of the pavement extend straight out and onto a horizon line (the first of two) also composed of grey concrete. In spite of their best attempts, these surface imperfections are denied the satisfaction of visual depth, even as they offer the viewer plenty to see.

Pratt's photographs depicting roads relate on a formal level to other works in which a wall of sorts—sometimes natural, more often constructed—splits the frame horizontally. Of these, *Shoreline Outcrop* (2016, p. 83) is a striking example, an image cut almost exactly down the middle by the top of what looks like a concrete retaining wall, below which is the rocky "outcrop" of the work's title. It is an imposing climb to reach the clouds above, and the sea is nowhere in sight (presumably behind us?). A photograph like *Soccer Pitch, Garnish* (2015, p. 85) forms a similar "wall"—in this case through a structure that Pratt is known for using—the quintessential east coast hunting, fishing, and/or utility shed—that blocks the viewer from the promise of scenery beyond. And then there is *Barricado* (2014, p. 47), a wonderful image that in title, form, and content forces the point of this vein of photographs within Pratt's work: the "natural splendour" that is Newfoundland is, quite literally, kept at bay, and we are asked to contend—in a minimalist gesture almost to the letter—*only* with what is before our eyes. In *Barricado* this is an ambiguously textured surface that carries the residual impacts of the environment and contours and lines that, arguably, one might never have noticed in any consequential way until now.

These works foreground directly what is there throughout the entirety of Pratt's diversely precise corpus: "the dregs, the things around us that others didn't seem to see or take seriously—the things that I saw every day." The things that have become Pratt's "visual world," forged sometimes on the side of a highway, somewhere along the shoreline, or far, far down a remote road servicing *New Lines* (2018, p. 87). It is there that he finds his place and waits, camera in tow, "for the environment to form a relationship with the structure." How he finds his exact sites to begin with is neither straightforward nor obvious, even to him. He speaks of how he often catches something potentially interesting in his peripheral vision, usually while driving, but also at moments when he is actually at a site to photograph something else. That new build in St. Mary's, for instance, that had yet to install its

windows and offered new framing potentials but that, in the end, didn't pan out for a variety of reasons, including the lack of distance that would have been necessary to make the precise angles required. While not all sites deliver, *all* the photographs are the result of an intuitive sense that within the landscape, just *that* place and *that* thing folded together through time and atmospheric circumstance will provide something novel, unique, and "ugly beautiful."

"It's almost like looking at a star," Pratt states by way of analogy. "You stare at it and you can't see it, but when you look over there, you can see it. It's a different quality of observing." We arrive at Cape Pine that evening under clear skies and heavy winds. Later, as the salt cod boils on the stove, Pratt calls me outside to view the endless flow of constellations above. If it weren't too much of a cliché, I'd say in that moment, in that place, I felt very, very small.

All quotes from Ned Pratt have been compiled from recorded conversations with the author at Pratt's St. John's studio or on the road to Cape Pine between May 15 and 20, 2018. Thank you to Ned Pratt, as well as to Andrée McGrath Pratt and Mireille Eagan, for your time, insights, and, above all, hospitality.

1. Sky Gooden, "A Parallel Landscape: Ned Pratt's Abstract Sublime," *Momus*, 24 March 2016. See http://momus.ca/a-parallel-landscape-ned-pratts-abstract-sublime/.

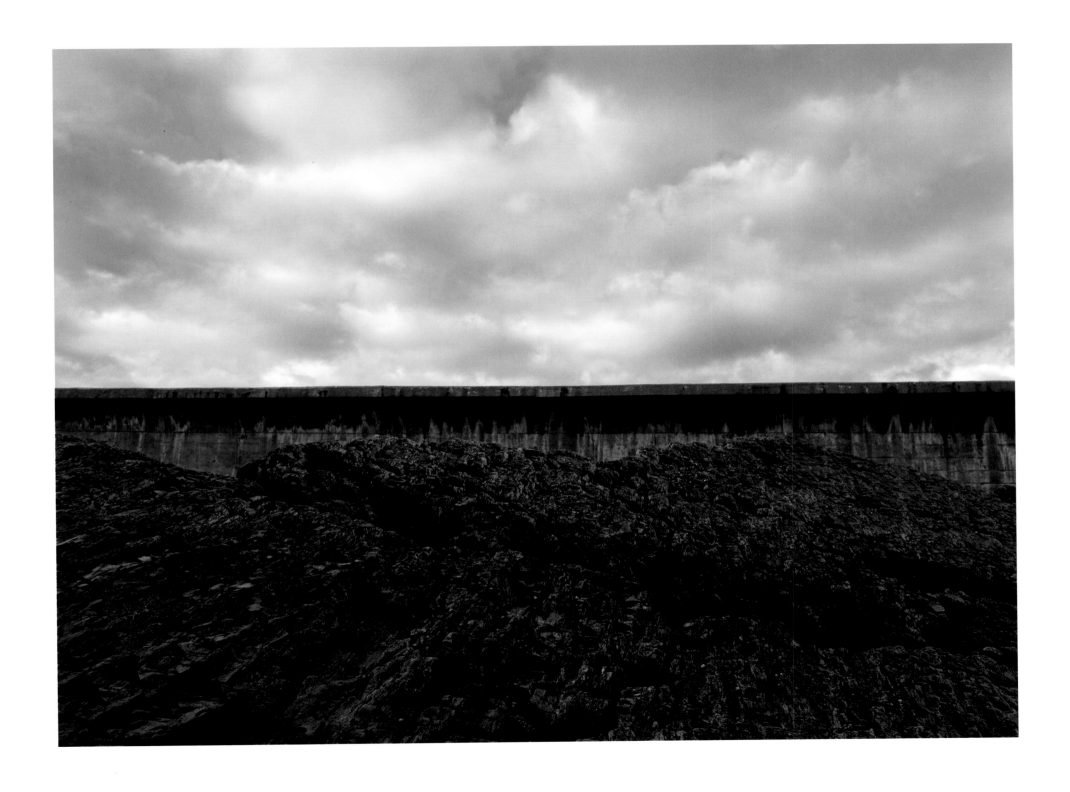

Shoreline Outcrop, 2016

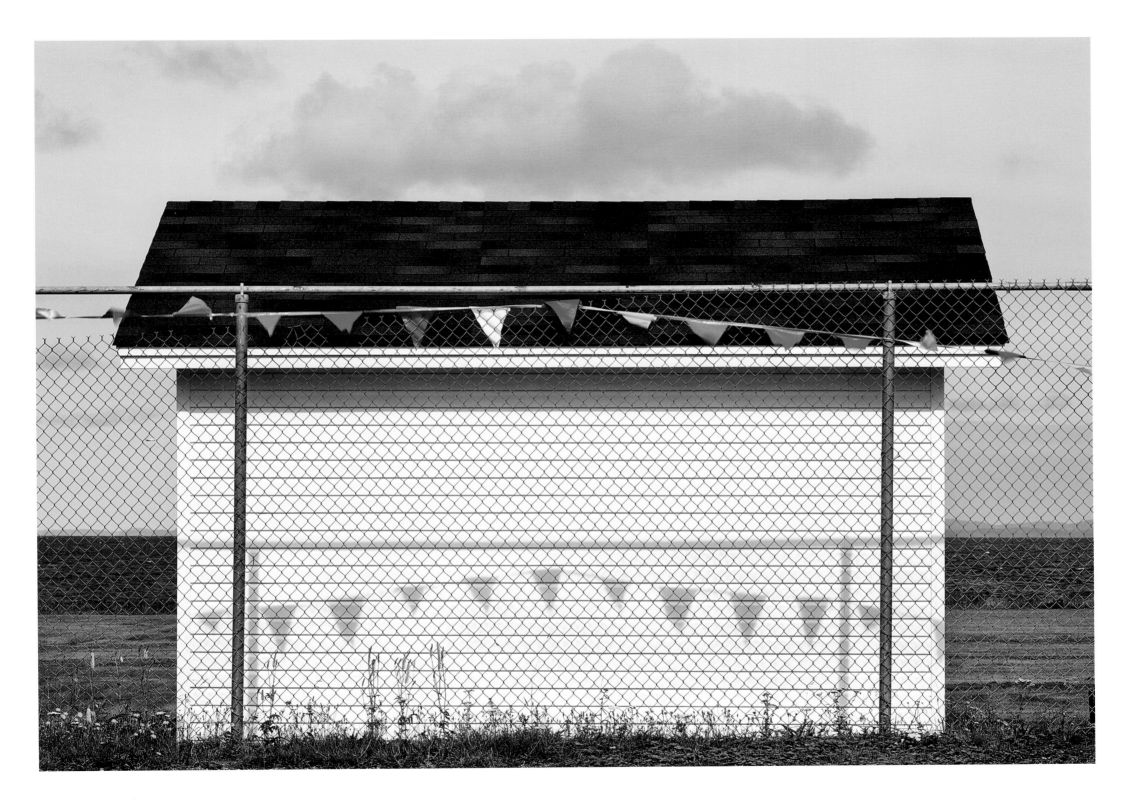

Soccer Pitch, Garnish, 2015

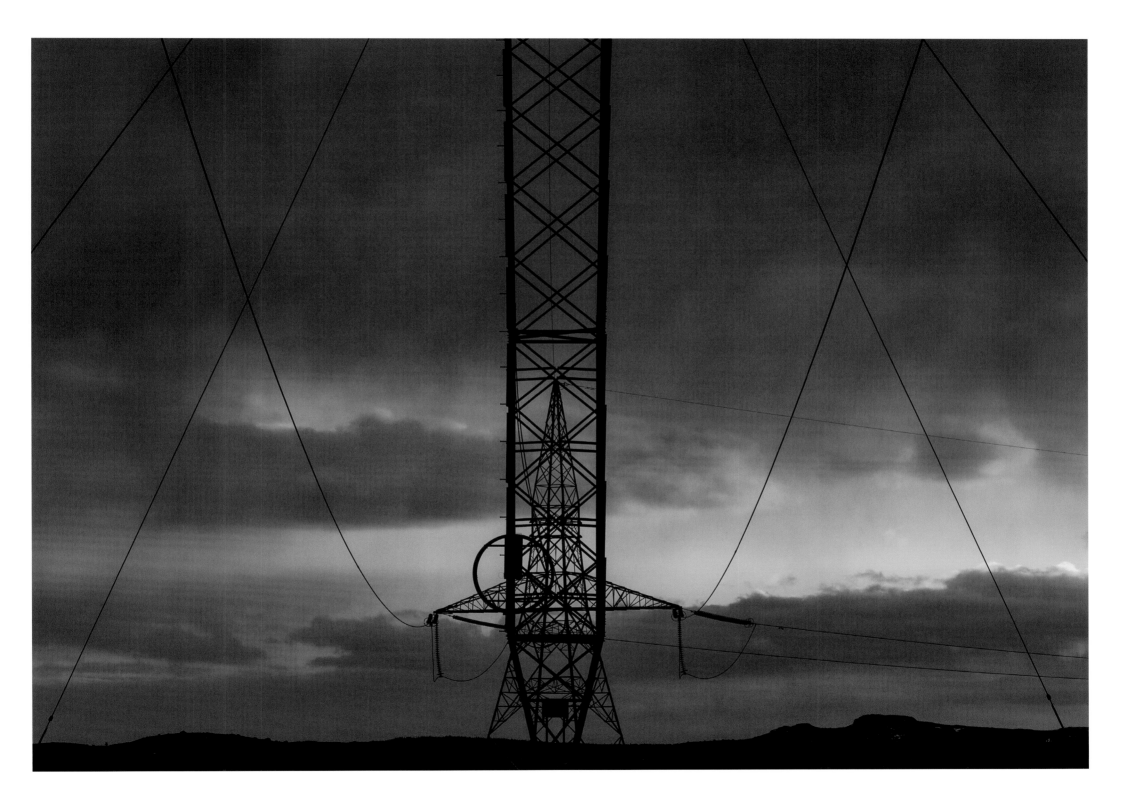

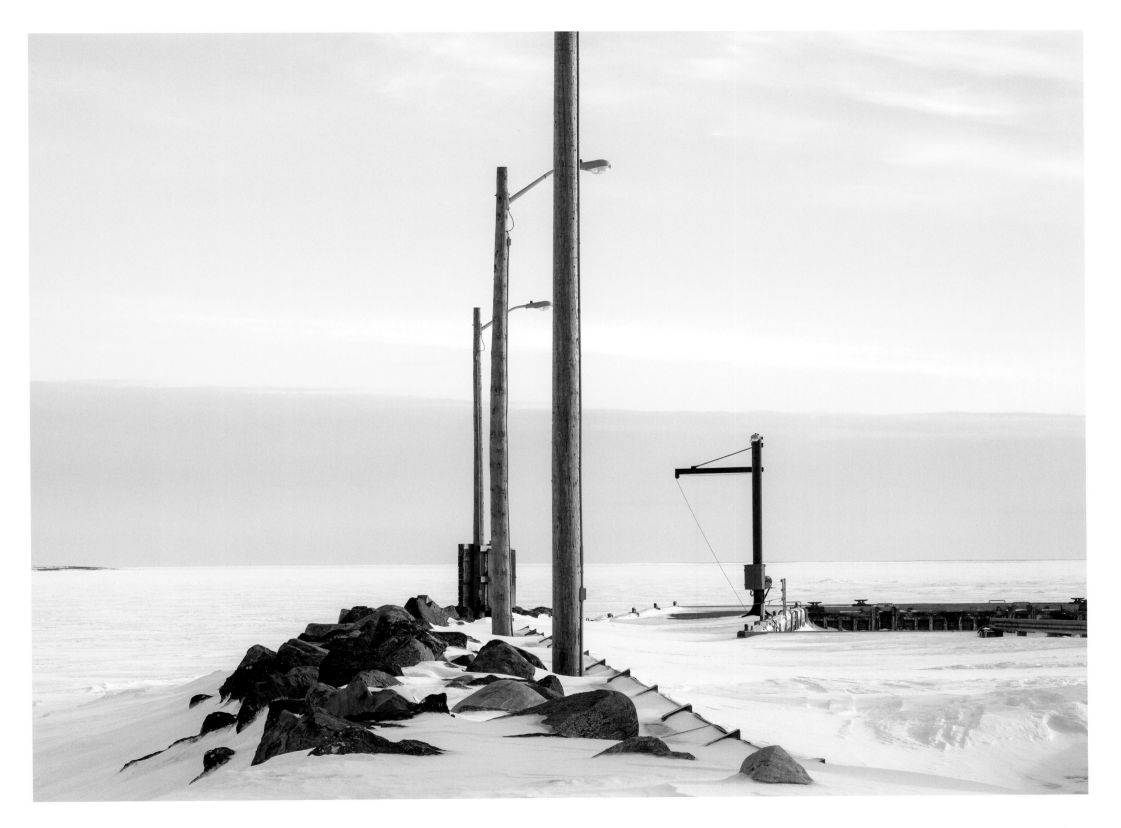

Government Wharf, Straight Shore, 2008

Water Reservoirs, 2018

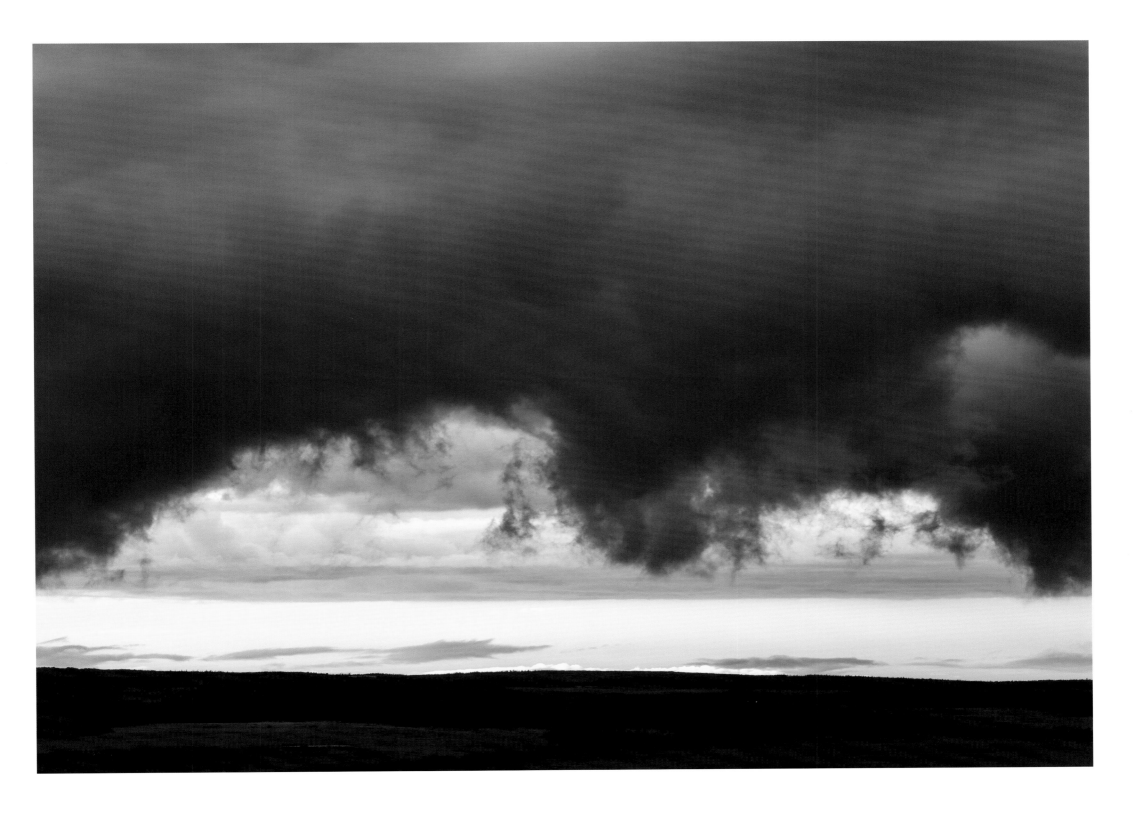

Approaching Weather, 2017

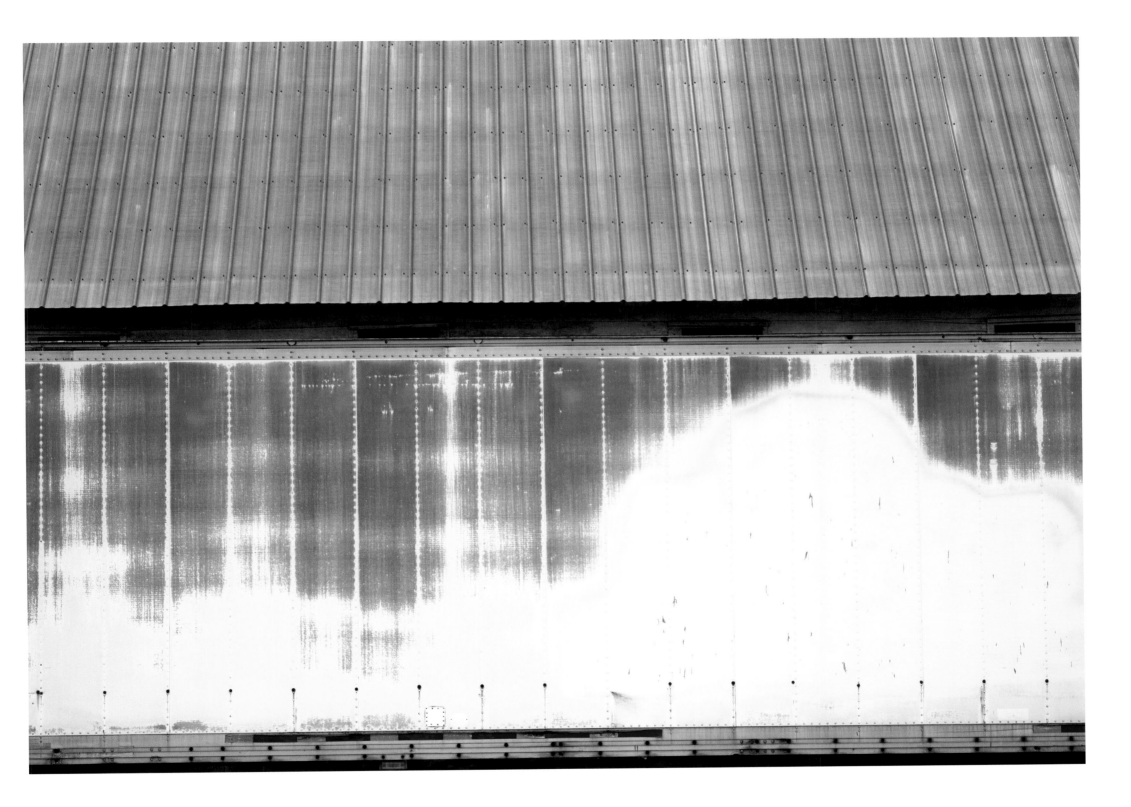

Trailer by an Old Church, 2017

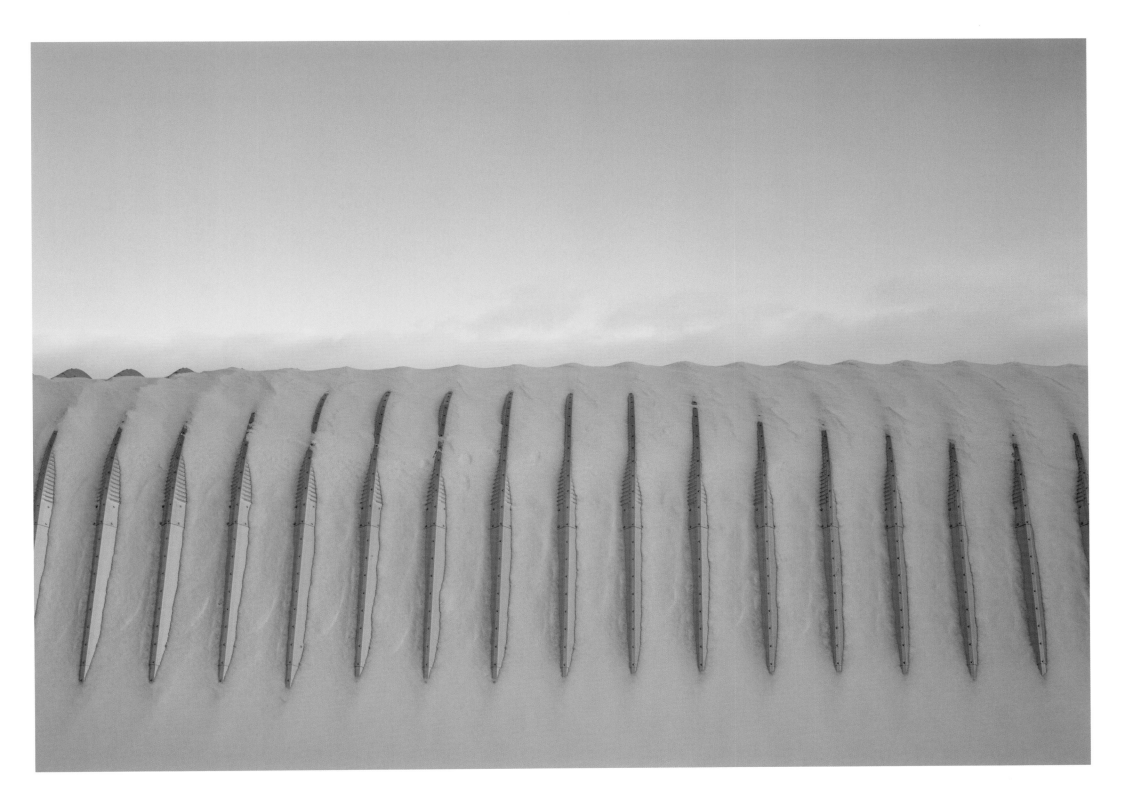

Quonset Hut, Sod Farm, 2017

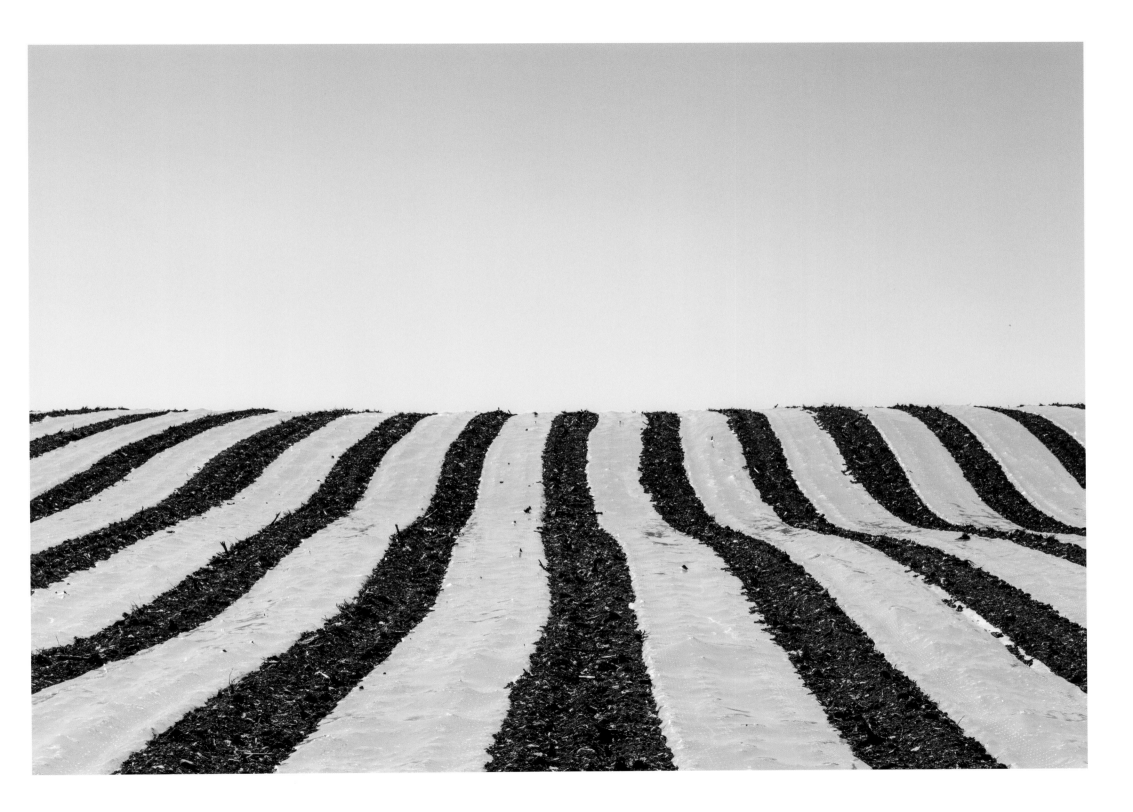

Cow Corn, The Goulds, 2017

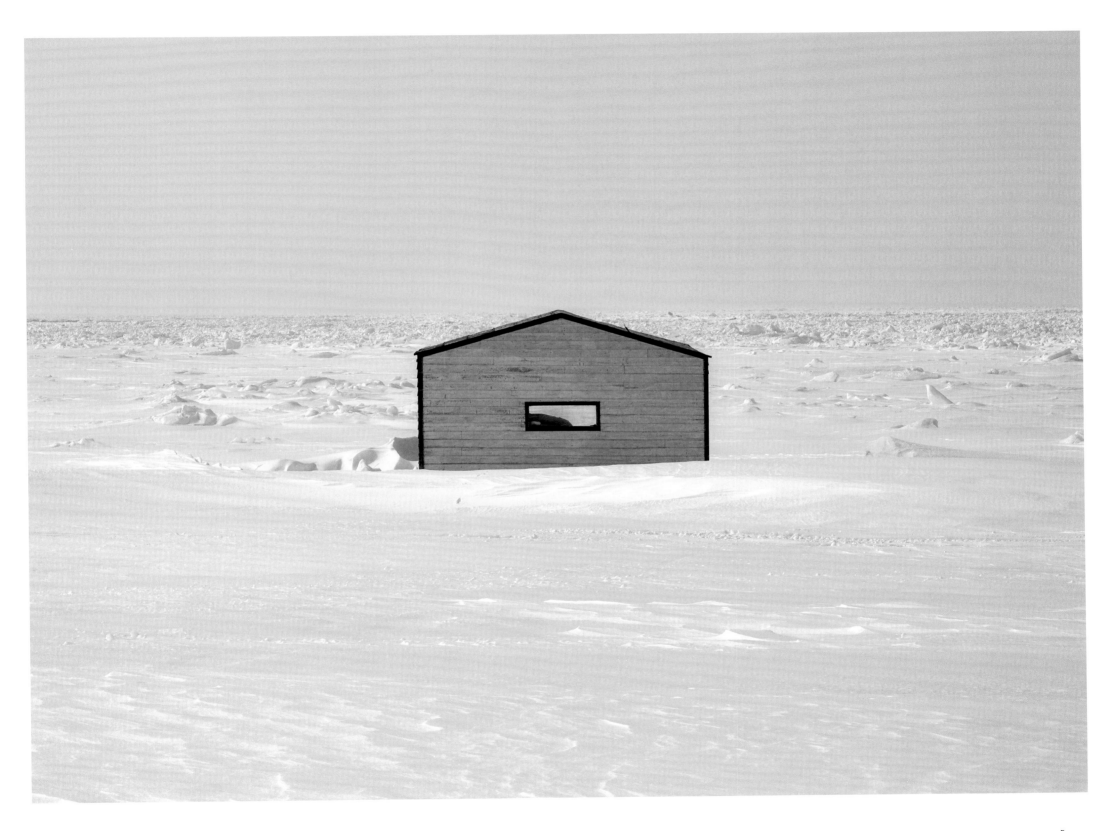

Façade, Northern Peninsula, 2008

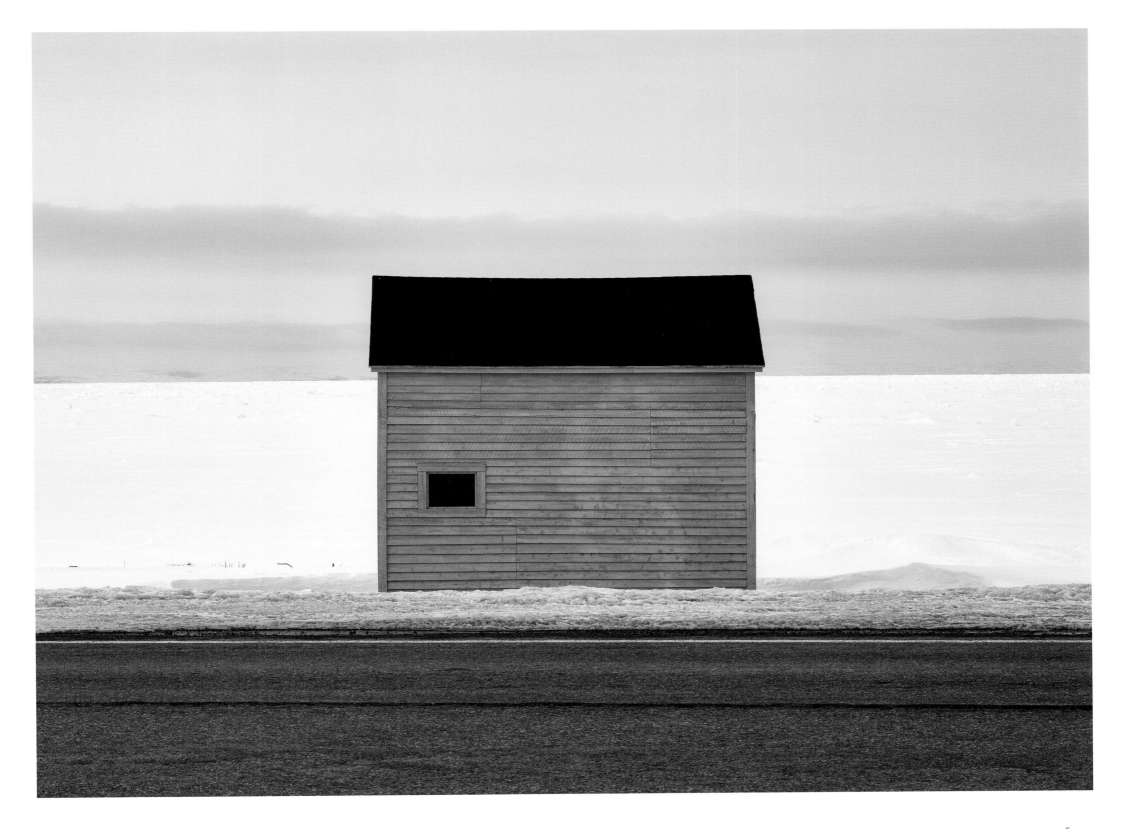

Pink Shed, Northern Peninsula, 2008

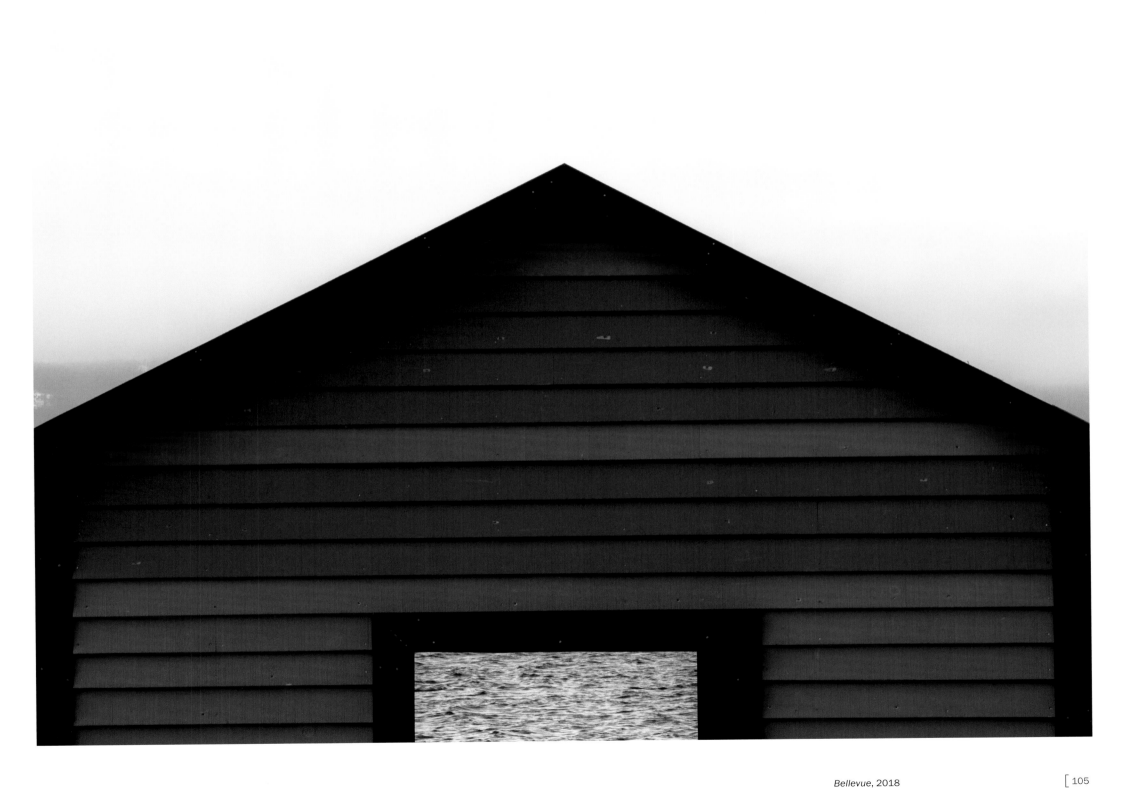

List of Works

Dimensions are provided as height x width.

* indicates the work was not exhibited in the exhibition mounted at The Rooms.

Blue Sky, 2001
colour photograph on Fuji Crystal Archive paper, 1/1
129 x 159.1 cm
Collection of the Art Gallery of Nova Scotia.
Purchased with financial support of the Canada
Council for the Arts, 2007.
Photo: RAW Photography.

Façade, Northern Peninsula, 2008
archival pigment print
88.26 x 118.11 cm

Government Wharf, Straight Shore, 2008
archival pigment print
88.26 x 118.11 cm

Miller Mechanical, Trinity Bay, 2008
archival pigment print
88.26 x 118.11 cm

Pink Shed, Northern Peninsula, 2008
archival pigment print
88.26 x 118.11 cm

Guardrail, 2009
archival pigment print
88.26 x 118.11 cm

Fogo Ferry, 2010
archival pigment print
88.26 x 118.11 cm

Trailer with a Red Stripe, 2011
archival pigment print
88.26 x 118.11 cm

Transicold Trailer, Herring Season, 2011
archival pigment print
88.265 x 117.475 cm

Barachois, Brackish Water, 2013
archival pigment print
88.26 x 118.11 cm

Yellow Berm, 2013
archival pigment print
88.26 x 118.11 cm

Barricado, 2014
chromogenic print
88.26 x 118.11 cm

Guy Wires, 2014
pigment-based archival print
88.26 x 118.11 cm

Insulator, 2014
archival pigment print
88.26 x 118.11 cm

**Barren Cabin, Tin Roof,* 2015
chromogenic print
83.82 x 117.47 cm

Connaigre Peninsula, 2015
chromogenic print
83.82 x 117.47 cm

Fog Horn Shelter, 2015
chromogenic print
83.82 x 117.47 cm

Harbour Entrance, 2015
archival pigment print
88.26 x 118.11 cm

**Jet*, 2015
archival pigment print
88.265 x 162.56 cm

Modern Architecture, Fogo, 2015
chromogenic print
83.82 x 117.47 cm

Soccer Pitch, Garnish, 2015
chromogenic print
83.82 x 117.47 cm

Aid to Navigation, 2016
chromogenic print
83.82 x 117.47 cm

**Backlit Structure,* 2016
chromogenic print
83.82 x 117.47 cm

Black Shed, Port-au-Port Peninsula, 2016
chromogenic print
83.82 x 117.47 cm

Lay-By, Wreckhouse, 2016
chromogenic print
83.82 x 117.47 cm

New Ferry, 2016
chromogenic print
83.82 x 117.47 cm

**Pack Ice, Northern Peninsula*, 2016
chromogenic print
83.82 x 117.47 cm

One Wave, 2016
chromogenic print
83.82 x 117.47 cm

**Shoreline Outcrop*, 2016
chromogenic print
83.82 x 117.47 cm

St. Philip's Beach, 2016
chromogenic print
83.82 x 117.47 cm

**Starboard Buoy*, 2016
chromogenic print
121.92 x 162.56 cm

Approaching Weather, 2017
chromogenic print
83.82 x 117.47 cm

Below a Drift, 2017
chromogenic print
83.82 x 117.47 cm

Cape Norman Lighthouse, 2017
chromogenic print
83.82 x 117.47 cm

**Cape Pine, Early Morning*, 2017
chromogenic print
83.82 x 117.47 cm

Cow Corn, The Goulds, 2017
chromogenic print
83.82 x 117.47 cm

End of the Wharf, Little Harbour, 2017
chromogenic print
83.82 x 117.47 cm

Fog Bank at Cape Race, 2017
chromogenic print
83.82 x 117.47 cm

New Wharf, Early Cribbing, 2017
chromogenic print
83.82 x 117.47 cm

**Outbuilding, St. Shott's,* 2017
chromogenic print
83.82 x 117.47 cm

Quonset Hut, Sod Farm, 2017
chromogenic print
83.82 x 117.47 cm

Radar Reflector, Port au Choix, 2017
chromogenic print
83.82 x 117.47 cm

Ruby Lumber Company, 2017
chromogenic print
83.82 x 117.47 cm

Trailer by an Old Church, 2017
chromogenic print
83.82 x 117.47 cm

Bellevue, 2018
chromogenic print
83.82 x 117.47 cm

New Lines, 2018
chromogenic print
83.82 x 117.47 cm

Water Reservoirs, 2018
chromogenic print
83.82 x 117.47 cm

Acknowledgements

The Rooms acknowledges the generous support of the Canada Council for the Arts. It is also grateful for the continued support of its Board of Directors and the Government of Newfoundland and Labrador. Thanks to all the staff at Goose Lane Editions, and to the editors for this edition, Meg Taylor and Leslie Vryenhoek. We are grateful to the external writers who found time in busy schedules to contribute to this catalogue: Ray Cronin, Sarah Fillmore, and Jonathan Shaughnessy. Thanks also to the Art Gallery of Nova Scotia for contributing images, and to the artists and organizations who also allowed us to use their images: Tim Brennan, Cora Cluett, Lois Conner, Thaddeus Holownia, and the Paul Strand Archive. Thanks to gallerists Nicholas Metivier and Christina Parker who contributed valuable advice. First and foremost, The Rooms wishes to thank Ned Pratt for his generosity in allowing us to share his creative process with our visitors and readers.

Ned Pratt extends thanks to The Rooms staff, in particular Anne Chafe, Mireille Eagan, Kate Wolforth, and the Technical Services team for bringing this exhibition and catalogue together. He is also grateful for the constant support of his mother and father; children, Jacob and Claire; and especially his wife, Andrée McGrath Pratt.

The Artist and Contributors

Ned Pratt (b. 1964) lives on the island of Newfoundland, where he was born and has spent most of his life. He holds a BFA in photography from the Nova Scotia College of Art and Design and a BA in art history from Acadia University. Newfoundland has inspired much of Pratt's artwork. His studio in St. John's—originally an old bakery, renovated using traditional carpentry—serves as the base for both his art practice and his commercial work.

Pratt's photography has been exhibited at the former Art Gallery of Newfoundland and Labrador, the McMichael Canadian Art Collection, PREFIX Photo, and The Rooms. His work was included in the 2012 Scotiabank Contact Photography Festival and in the exhibition *Oh, Canada* at the Massachusetts Museum of Contemporary Art (2012–13) and subsequent tour (2013–16). He holds the 2017 Large Year Award from VANL-CARFAC for Excellence in the Visual Arts. His work has been written about in *Canadian Art*, *CBC Arts*, *MOMUS*, and *Mason Journal*, among others. Pratt's photographs are held in major public and corporate collections, including the Art Gallery of Nova Scotia, BMO, Global Affairs Canada, McCarthy Tetrault, Royal Bank of Canada, The Rooms, Scotiabank, TD Bank Group, and Torys. His work is also held in private collections across Canada, the United States, Europe, and Australia. He is represented by Christina Parker Gallery in St. John's and Nicholas Metivier Gallery in Toronto.

Ray Cronin is a writer and curator based in Nova Scotia. He is the former Director of the Art Gallery of Nova Scotia, the founding curator of the Sobey Art Award, and a frequent contributor to Canadian and American art magazines. He is the author of *Alex Colville: Life & Work* (Art Canada Institute, 2017), *Mary Pratt: Still Light* (Gaspereau, 2018), *Gerald Ferguson: Thinking of Painting* (Gaspereau, 2018), and *Our Maud: The Life, Art and Legacy of Maud Lewis* (Art Gallery of Nova Scotia, 2018), and a contributor to numerous other exhibition

catalogues and art books, including *Mary Pratt* (AGNS / The Rooms / Goose Lane Editions, 2013) and *Graeme Patterson: Secret Citadel* (AGNS / Art Gallery of Hamilton, 2014).

Mireille Eagan is Curator of Contemporary Art at The Rooms in St. John's. She has curated more than 70 exhibitions, including the two-part series *Future Possible: Art of Newfoundland and Labrador*; *Jenny Holzer: Truisms*; and *Christopher Pratt: The Places I Go*. She co-curated the nationally touring retrospective *Mary Pratt: This Little Painting* for the National Gallery of Canada, and *About Turn: Newfoundland in Venice, Will Gill and Peter Wilkins* for the Terra Nova Art Foundation's Collateral Project at the 55th Venice Biennale. She has been published in catalogues for private and public galleries and written for national magazines and periodicals including *Border Crossings, C Magazine, Canadian Art,* and *Visual Arts News*. Eagan holds an MA in Art History (Concordia University, 2008).

Sarah Fillmore is Chief Curator and Deputy Director of Programming at the Art Gallery of Nova Scotia. Fillmore is a champion of emerging Canadian artists, with an interest in Atlantic Canadian art within a national context. She has curated group and solo exhibitions, including the retrospective exhibition of Canadian abstract painter Jacques Hurtubise; *Lisa Lipton: STOP@forever*; *SKIN: the seduction of surface*; *Forces of Nature*; *The Last Frontier*, and, from 2002 to 2015, the annual Sobey Art Award exhibition. She co-curated *Hanson and Sonnenberg: The Way Things Are* with David Diviney (Art Gallery of Nova Scotia); Graeme Patterson's *Secret Citadel* with Melissa Bennett (Art Gallery of Hamilton); and the touring retrospective and accompanying publication of Canadian realist painter Mary Pratt, with Mireille Eagan and Caroline Stone (The Rooms). Recent projects include a retrospective of Canadian painter Marion Wagschal, presented at the Musée des beaux-arts de Montréal, as well as a solo exhibition of Halifax-based painter Emily Falencki, an exhibition of Montreal-based printmaker Mitch Mitchell's large-scale print installations, and a career survey of photographer Thaddeus Holownia's work.

Jonathan Shaughnessy is Associate Curator, Contemporary Art at the National Gallery of Canada. His most recent exhibitions include the *2017 Canadian Biennial* in Ottawa and *Turbulent Landings: The NGC 2017 Canadian Biennial* at the Art Gallery of Alberta, Edmonton. In 2015–16 he organized *Mary Pratt: This Little Painting* in collaboration with Mireille Eagan and The Rooms; in 2014 he curated *Vera Frenkel: Ways of Telling* at the Museum of Canadian Contemporary Art (now the Museum of Contemporary Art), Toronto. He has written extensively on contemporary art and artists working in Canada and internationally, and is an Adjunct Professor in the Department of Visual Arts at the University of Ottawa.

Index

Published in conjunction with the exhibition *Ned Pratt: One Wave*, organized by
The Rooms, St. John's, NL, September 22, 2018 to January 20, 2019, and touring
nationally 2019-22.

Edited by Meg Taylor and Leslie Vryenhoek.
Cover and page design by Julie Scriver.
Front cover: Ned Pratt, *St. Philip's Beach* (detail), 2016, chromogenic print,
83.82 x 117.47 cm.
Back cover: Ned Pratt, *Approaching Weather* (detail), 2017, chromogenic print,
83.82 x 117.47 cm.
All dimensions of artwork are given in centimetres, height preceding width
Printed in Canada by Friesens.
10 9 8 7 6 5 4 3 2 1

We acknowledge the generous support of the Government of Canada, the Canada
Council for the Arts, the Government of New Brunswick, and the Government of
Newfoundland and Labrador.

Library and Archives Canada Cataloguing in Publication

Pratt, Ned, 1964- [Photographs. Selections]
 Ned Pratt : one wave.

Accompanies an exhibition held at the Rooms in the fall 2018.
Co-published by The Rooms Corporation of Newfoundland and Labrador.
ISBN 978-1-77310-086-9 (hardcover)

1. Pratt, Ned, 1964- --Exhibitions.
2. Exhibition catalogs.
I. Eagan, Mireille, 1982-, writer of added commentary
II. Fillmore, Sarah, writer of added commentary
III. Cronin, Ray, 1964-, writer of added commentary
IV. Shaughnessy, Jonathan L., 1972-, writer of added commentary
V. Rooms Corporation of Newfoundland and Labrador, issuing body, host institution
VI. Title.
VII. Title: One wave.

TR647.P73 2018 779.092 C2018-901437-7

Goose Lane Editions
500 Beaverbrook Court, Suite 330
Fredericton, NB
CANADA E3B 5X4
www.gooselane.com

The Rooms Corporation of Newfoundland
and Labrador, Provincial Art Gallery Division
9 Bonaventure Avenue
P.O. Box 1800, Station C
St. John's, NL
CANADA A1C 5P9
www.therooms.ca